Fresh
Watercolour

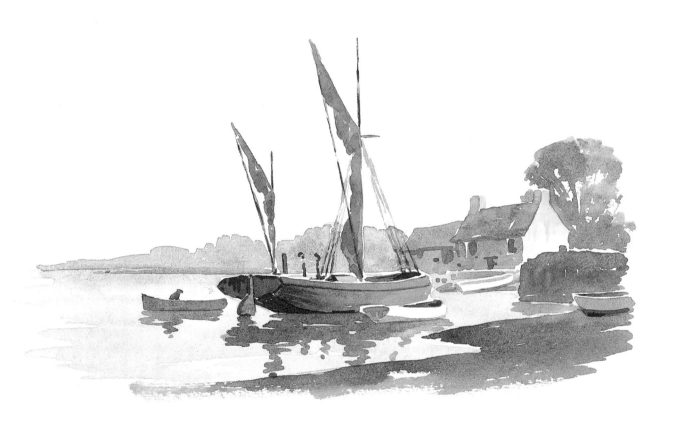

BRING LIGHT & LIFE TO YOUR PAINTING

Fresh Watercolour

RAY CAMPBELL SMITH

dc
David & Charles

To my family, my friends and fellow painters, and all those who share my love of pure watercolour

Title page illustration: **The River Frome**
(10¾ × 15in)

British Library Cataloguing in Publication Data
Smith, Ray Campbell
 Fresh watercolour.
 1. Watercolour paintings
 I. Title
 751.422

A DAVID & CHARLES BOOK

First published 1991
Reprinted 1991, 1992, 1993, 1994 (twice)
First published in paperback 1995
Reprinted 1996, 1998, 1999

A catalogue record for this book is available from the British Library.

ISBN 0 7153 0294 9

Book design by Michael Head
Typeset by Typesetters (Birmingham) Ltd,
Smethwick, West Midlands
and printed in Hong Kong by Wing King Tong Co Ltd
for David & Charles
Brunel House Newton Abbot Devon

Contents

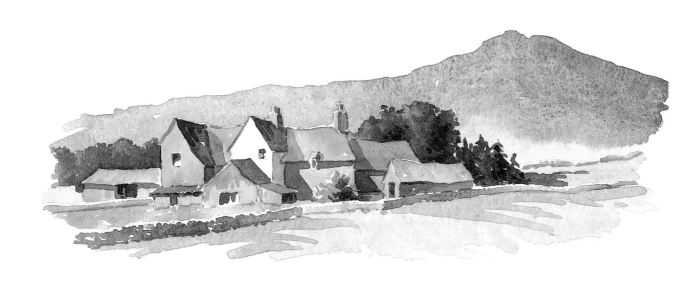

Introduction

Watercolour, in skilled hands, can produce irresistible paintings! There is nothing like it for conveying, quickly and freshly, the essentials of an atmospheric landscape. Its transparent and translucent washes allow the paper to shine through to convey an impression of light flooding the countryside. Although watercolour adapts to a variety of styles, it is perhaps at its most effective and appealing when it is used boldly, quickly and impressionistically and indeed many of the watercolours we admire most look as though they were painted in a very few minutes. This appearance of spontaneity is deceptive and hides a great deal of careful thought and planning.

You probably have a good idea of the effects you are aiming for when you sit down to paint. But how many times have those loose and fluid visions, which inspired you to have a go, gradually faded as overworking and overcomplication take over? And how depressing to see the tired and muddy watercolours mount up! It is enough to make you give up in despair and yet you can learn a great deal from them if you can bring yourself to analyse them objectively. There are many reasons for such failures, but they can all be boiled down to lack of planning and lack of forethought. The beginner will often apply a wash without thinking ahead. If it does not produce the effect he wants – if, for example, he has not allowed for the fading that occurs as watercolour washes dry – he may modify it, perhaps several times, and before he realises what is happening, freshness and clarity will have been lost. What he should do is to analyse the effect he wants to create, plan carefully the manner in which to achieve it, perhaps testing for tone and colour on scrap paper, and then go ahead boldly and purposefully applying his washes. Once applied these washes should be left alone, for the more prodding and pushing about they receive, even while still wet, the more they will lose freshness. Even if the effect is not quite as intended, it will probably be far fresher and more effective than some much modified version. What it really amounts to is: 'Think first, paint later'.

Complicated and crowded landscapes are a fertile source of difficulty and cause the inexperienced painter to get bogged down in a morass of detail that would be all the better for a bit of drastic simplification. Here is an example of the simplifying process: In the painting, *Tranquil Harbour*, the far hillside was a mass of houses, roofs, chimneys, trees and so on. If all these buildings had been painted individually, the whole passage would have received far more attention than it warranted, and would have competed with the foreground boats and jetty. So a conscious decision had to be made to play it down and simplify it, with the help of an on-the-spot sketch. In the event all it received was a single greyish wash in which odd geometric shapes were left to stand for the houses, roofs, and other details. This broad suggestion of buildings leaves a lot to the imagination but watercolour is often at its most effective when it suggests and does not depict in minute detail. This piece of simplification has been described at some length because it typifies the sort of decision the watercolour painter is frequently called upon to make. You will paint with greater effect and authority if you constantly ask youself, 'how can I suggest that complicated passage with conviction and economy without committing myself to painting masses of fiddling detail?' This forward planning and bold execution will pay off every time. It is really a matter of reducing the landscape to simpler terms which watercolour can handle.

So far we have been considering very broadly watercolour technique – the most effective way of putting paint on paper – but this is only part of the story. Even more important is the problem of conveying to others the emotional response we felt when a particular scene first claimed our attention. This, of course, is vitally important for unless we can convey this feeling in our treatment of the subject, our painting, however expert the technique, will have little impact.

Occasionally we come across a scene that simply cries out to be painted and this is a real bonus; more frequently it is a particular aspect of

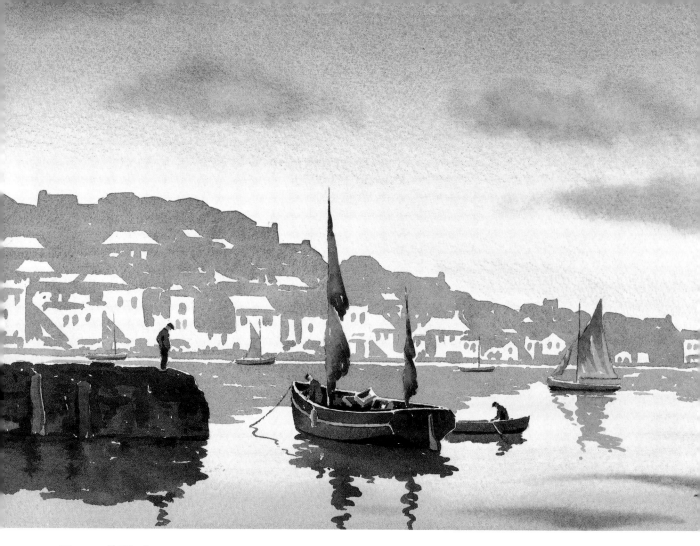

Tranquil Harbour (10¼in × 14¾in)
The attraction of this Cornish scene was the sense of peace it engendered together with the liquid shine of the calm water. These qualities are best conveyed by the use of broad, clear washes. Two pools of colour were prepared, the first of ultramarine with a little light red, the second of raw sienna, also with a touch of light red. The first wash was applied with horizontal sweeps of a 2in flat brush, starting at the top. About a quarter of the way down, the brush was dipped in the second wash, producing a gradual transition from grey/blue to the warmer colour of the lower sky. This sequence was reversed for the lower part of the water. While the paper was wet, but not too wet, the soft-edged clouds were put in with ultramarine and light red and their warm glow indicated with a touch of dilute raw sienna, care being taken to avoid the unwelcome phenomenon known as 'flowering' or 'fanning', a problem dealt with in Chapter 6. A couple of horizontal strokes with the same grey suggest the soft ripples of the right foreground, again wet into wet.

While all this was drying, the treatment of the far hillside was considered (see p7). The reflection of the hillside was then painted with an ultramarine and light red wash, care again being taken to preserve the highlights on top of the jetty and boat. This reflection actually extended lower than shown, but it was important to preserve the patch of shining water *between the jetty and the large boat. This is the sort of liberty the painter can sometimes take – a liberty the photographer may well envy. It only remained to paint in the foreground objects boldly and strongly, to bring them forward and make the background recede and, finally, to add their reflections with quick strokes of the brush.*

a familiar scene that evokes a response, perhaps the way dappled shadows fall across a country lane, the way a group of sunlit buildings stand out against a dark shoulder of moorland, or any one of a hundred things that capture our imagination. Whatever the attraction we must be sure to give it due emphasis so that in our painting we proclaim: '*This* is what grabbed me!' In this way we will share our experience with others and this sharing of emotion is surely what painting is all about. So the process should be observing, absorbing, feeling, mentally translating impressions into watercolour terms – and then planning a strategy.

One of the questions frequently asked is: 'How much drawing should I do before I start painting?' Unfortunately there is no straightforward and unequivocal answer to this question for it really all depends upon the degree of complexity

of the subject. If we are considering a simple landscape with just fields and a few trees, then we can go straight in with the brush. If, on the other hand, we are tackling a complicated scene with perhaps buildings at varying angles, then perspective and composition will need careful handling, and some considered drawing will be necessary. But do not use the pencil more than you have to for it is a mistake to draw so much detail that the painting process is simply a matter of colouring the areas between the lines, rather in the manner of a child's colouring book. It is much better to allow the brush freer rein, so that the rhythm of the brushstrokes lends character to the painting.

Progress in watercolour painting is not a regular or uniform process and there are times when every painter finds he is not breaking new ground and may even feel he is becoming stale. This is the time to try something new and experimental and watercolour is a medium that encourages this sort of break with tradition. One answer to the problem is doodling! Mix up several washes and simply paint or even pour them onto your paper, with no preconceived plan. Let these washes flow and blend and do what they will. Often the result will be a mess, but occasionally it will be interesting or even exciting and perhaps suggest something to you which a few deft strokes may bring to life. These happy accidents *do* occur in watercolour and the trick is to recognise them when they arise, preserve them and perhaps thereafter add them to your repertoire. In this way technique develops and imagination is stimulated.

We are frequently told that practice is the key to progress and although this is broadly true, painting is a creative process and our best work is done when we are really in the mood. An enquiring mind, a roving eye (in a strictly artistic sense) and an awareness of our surroundings will all help to stimulate our imagination and provide the inspiration that every painter needs.

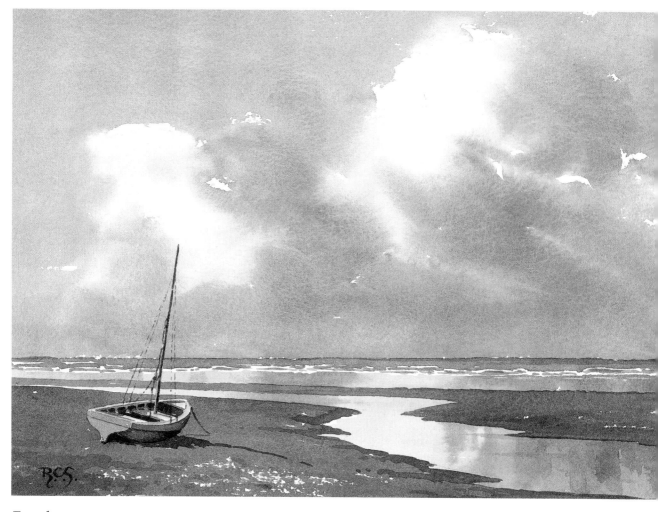

Foreshore (10½in × 14½in)

*This is a quick watercolour impression of an evening
scene dominated by a mass of shining cloud reflected
in the bands of wet sand and still water. The cloud
and its reflection caught the imagination as the
treatment makes apparent, with the deep tones of the
foreground emphasising the shine of the water.*

*Not a lot of drawing is necessary here, just an
indication of the horizon and the margins of the
stream, to make sure the water lies flat and does not
appear to flow uphill. The subtle lines of boats also
need careful handling for incorrectly drawn boats can
look remarkably unseaworthy. The boat helps to
balance the main cloud mass and its inward-leaning
mast directs the eye into the painting.*

Doodle no 1

*A start was made by splashing on a liquid mix of raw
and burnt sienna and another of ultramarine and light
red. A tree shape suggested itself, so that theme was
developed and with a brush loaded with Winsor blue
the first washes were blended and extra leaves, fence
posts, shadows and so on added.*

Church Close, Rye (10¾in × 14½in)
This is an example of a fairly complex scene where considerations of composition and perspective suggest some careful preliminary drawing. The important subjects of composition and perspective are both dealt with later in the book. For the present there are several points worth noting:

1 *The treatment of the sky has been kept very simple so that it does not compete with the busy scene below.*
2 *The massive stone buttress on the left helps to balance the large house on the right and also prevents the eye following the pathway off the painting to the left.*
3 *The figure stands out against a patch of light and is walking into the painting rather than out of it.*
4 *Lights have been placed against darks wherever possible to provide contrast and create a three-dimensional effect.*

Doodle no 2
A series of wild, vertical brush strokes made with the side of a large brush, loaded with a wash of raw and burnt sienna, immediately suggested some long grass or cereal crop, so some shadows were put in with ultramarine and burnt sienna and an impression of poppy heads added with light red.

1
The Challenge of Choosing Subjects

Painting good watercolours is a difficult business. It is beset by a number of problems which all have to be faced and overcome. That is no easy task and we should not make it harder by putting up with unnecessary difficulties. Using unsuitable or inferior materials – more of this later – makes good watercolour painting infinitely more difficult, and choosing unsuitable subjects is another way of adding to the problems. Beginners are understandably beguiled by magnificent but daunting panoramas and by spectacular sunsets that would give a Turner pause for thought. At least in the early stages they would do well to lower their sights a little and tackle subjects more comfortably within their range and within the scope of the medium. Watercolour is a delicate and subtle medium and is not at its best when pushed to the limit.

A breathtaking panorama does not usually make a good watercolour subject unless there is a considerable amount of simplification. Hill villages, for instance, are appealing subjects but it is all too easy to become embroiled in their mass of detail to the detriment of the overall impression. Faced with a magnificent sweep of country, it is usually better to select a small part of it as a subject and this is where a home-made viewfinder can be of assistance. This is simply a piece of stiff card, such as an off-cut of mounting board, with an aperture cut in it about the size and shape of

a postcard. This simple device makes it possible to isolate a promising subject from a mass of surrounding detail. The lines which form the edge of the watercolour paper are an integral part of the composition and have to be considered in conjunction with the principal construction lines of that composition, so the edges of the aperture in the viewfinder, which frame the subject, will help in that respect as well.

Painters should cultivate open and receptive minds so that they immediately recognise good subject matter whenever and wherever they come across it. Beginners sometimes make up their minds in advance about the subjects they wish to paint and then waste fruitless and frustrating hours searching for that ideal but elusive subject, while ignoring the many other opportunities on offer. They sometimes find it difficult to free themselves from conventional notions of the picturesque and assume that the only good subjects are attractive ones. This is not to say they should seek out ugliness for its own sake or consider all beauty to be hackneyed. Nor should subjects be taboo simply because they have been painted many times before, provided the treatment is imaginative and says something new and original. It is always worth bearing in mind that form and tone and colour are what really matter and these can be found to advantage in a wide range of subjects, conventional or otherwise. It is

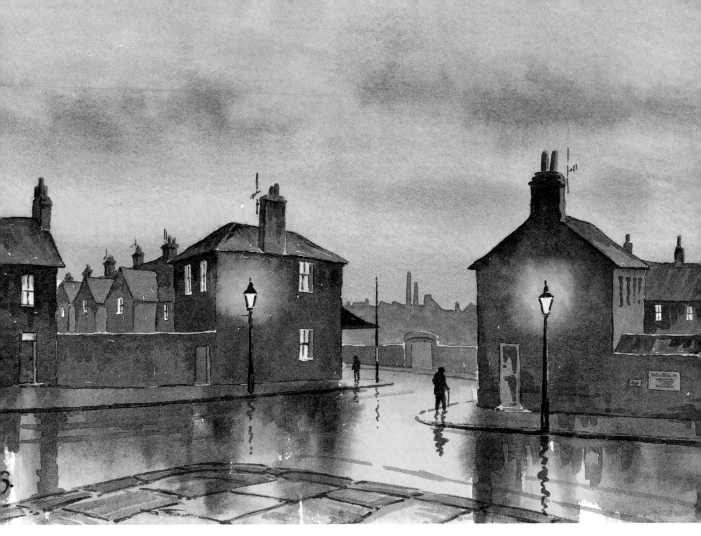

all a matter of using your eyes and imagination.

The typical art club programme lists painting trips to attractive rural locations and there is nothing wrong with that, for from the beginning art has held a mirror up to nature. But we are, perhaps, too inclined to turn automatically to the beauties of the countryside for our inspiration and ignore promising subjects in our towns. This is partly a form of escapism and partly an ingrained conviction that art and nature are inseparable. Whatever the reason the result is that the urban scene, often rich in character and atmosphere, is neglected. It is not only the Grand Canals and the Princes Streets that are worth painting; many of the older, run-down districts have an appeal of their own. A good time for painting such scenes is dusk when a warm light may suffuse the sky, an evening mist may soften the harsh outlines and lights begin to appear in windows and shop fronts. Metalled roads normally have little to offer the painter, but if they are wet with rain and reflect the lights and darks above, they can add greatly to the interest and appeal of a painting. *Street Corner* is an example of this type of subject. Here the soft evening light casts a warm glow over an undistinguished scene and is reflected in the wet road and pavement

Street Corner (10¼in × 14¾in)
Here the aim was to capture the softening effect of warm evening light upon a somewhat unpromising urban scene. The sky was a graded wash from cool to warmer colour approaching the horizon, with soft-edged clouds put in with a mixture of ultramarine and light red while the paper was still damp. Only three colours were used in this painting, the third being raw sienna (the advantages of a limited palette are described in Chapter 4). The main feature of this painting is the shining patch of wet road in the centre and this has been emphasised by the two dark figures placed against it. Notice how the lights in the windows appear to shine against their dark surroundings and how the street lamps shed their radiance against the dingy walls behind. Notice, too, how the lines of the pavements and walls direct the eye to the centre of interest, in this case the gap between the buildings.

below. The drab masonry is enlivened by glowing rectangles as lights are switched on and in the distance is the merest suggestion that this is an industrial area. Not a conventionally attractive scene, perhaps, but one that has atmosphere.

As you gain in experience and come to know your own strengths and weaknesses more intimately you will begin to see your subject matter in watercolour terms and will instinctively know how you will treat the constituent parts. This knowledge will assist you greatly in your search for subject matter and will help to shape your choice. Whatever you choose to paint, you should always remember that atmosphere and character and feeling are infinitely more important than mere topographical accuracy.

The Whelk Sheds (12¼in × 18in)
The unplanned jumble of fishermen's huts, with their variety of building materials, contrasts with the horizontal lines of sea and saltings on the left of the painting to make an interesting composition. The lively sky, with its billowing clouds, suggests a low horizon. The deep tones of the chimneys and roof register convincingly against the paler washes of the sky and the strongly painted shadows help to impart a three-dimensional quality to the buildings. The rough grass in the foreground has been painted in boldly and freely to contrast with the pale sandy track and the smooth expanse of water on the left.

Montmartre (13in × 9¾in)
Another example of how an undistinguished side street can make an interesting subject. The narrow road zigzags into the centre of interest where a figure is silhouetted against a pale background. Once again the road surface is wet from a recent shower and so reflects the lights and darks of the buildings above.

Golden Green Village (10½in × 16¼in)
This group of houses, barns and trees, caught by the early evening light, makes a simple yet satisfying composition. Although rather strung out in a line, the buildings overlap and are connected together by the trees, hedges and a brick wall. This allows the various elements to relate to one another and form a cohesive whole. The contrasting lights and shades of the buildings emphasise the strong lateral light. The treatment of the foreground field has been kept simple to avoid any competition with the scene above.

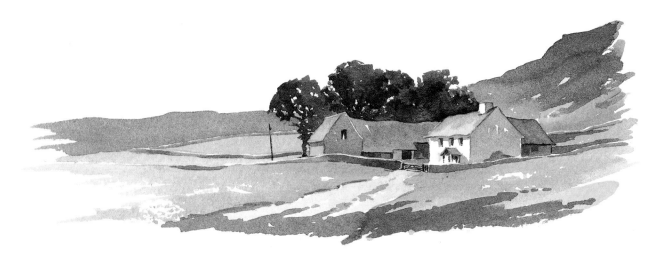

2
Now for Composition and Tone

Once you have decided what you are going to paint, the next problem is to get it down on your watercolour paper. If the subject is at all complex you will be lucky if you can avoid some erasing and yet, as you know only too well, you will never achieve a really clear, fresh wash on a surface which has felt the rubber. So what can you do? Firstly, you can use a putty rubber which will do less damage to your precious surface than the india-rubber variety and, secondly, you can adopt a different approach altogether.

It is a good plan to make several lightning sketches of your chosen subject from a number of different viewpoints, using charcoal or 4B pencil. Then make a full-sized sketch of the most pleasing of these quick impressions and transfer it to your watercolour paper. In this way all your false starts and alterations are resolved in advance. If the composition is a simple one, copying it will present no problems. If, on the other hand, the shapes are tricky, you can use a tracing technique. First scribble with the stub of an old B pencil on the back of your sketch, and using thin sketching paper makes it easy to see where the main construction lines occur. Then, placing the sketch onto your watercolour paper,

and using a sharp pencil or ballpoint pen, trace the principal lines of the composition on to the paper beneath. Of course, if you are tackling a very simple scene, without any problems of composition or perspective, you would probably dispense with preliminary drawing altogether. As you gain in experience, so you will manage with less and less drawing and your work will gain in freshness and spontaneity as a result.

So far we have rather skirted round the important question of what makes a good composition. This is a question we must now face and it is a difficult one. We can say, of course, that a well-composed painting is easy on the eye and has a harmony and a balance that we find pleasing, but it is much harder to state in simple terms why this should be so. In practice it is probably more helpful to list the commonest faults and then suggest ways of avoiding them.

There are all sorts of ways in which violence can be done to good composition, but there are ten faults which seem to crop up with the greatest frequency. These are listed below; with each description there is a sketch illustrating that particular fault, and another showing how it may be avoided.

1 A very common fault is that of placing a dominant horizontal line exactly halfway up the paper. This line could well be the horizon, in which case you should ask yourself whether you are more interested in the foreground or in the sky, and adjust

the position of the horizon, up or down, accordingly. If, for example, you are painting a stretch of empty marshland, you may well be more interested in the sky above, and will settle for a very low horizon.

 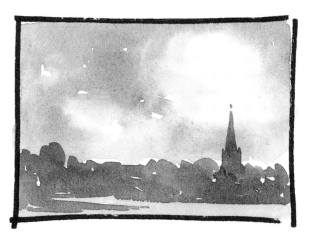

2 Related to this is the fault of placing a dominant vertical feature, such as a steeple, exactly halfway between the right- and left-hand margins of the paper.

Much better to move the object in question a bit to one side and then seek some way of achieving balance.

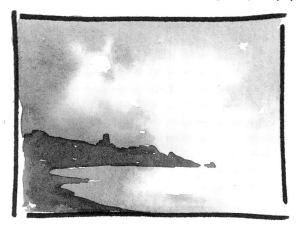 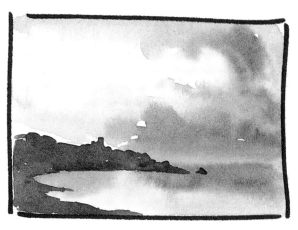

3 Failure to achieve tonal balance is the third fault in the list. Unless you have worked out your composition carefully, it is all too easy for most of the tonal weight of the painting to end up on one side or the other, imparting a lop-sided feeling to your work.

This imbalance may well be inherent in the chosen subject, but it is then up to you to do something about it. In the accompanying sketch balance has been restored by simply moving the heavy cloud mass to the right.

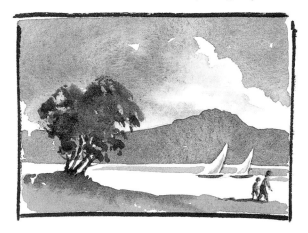 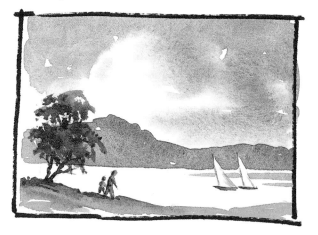

4 One of your aims should be to keep the viewer's eye firmly on your painting by doing all you can to prevent it moving off the edge. Most good paintings have a 'centre of interest', the significant part of the painting to which the artist wishes the eye to travel and come to rest. You therefore have to avoid anything that carries the eye away from this

important area. In the left-hand sketch the sailing boats are moving off the paper to the right, as are the figures; the trees are all leaning to the right and even the hills and clouds seem to be pointing in the same direction. By contrast, in the right-hand sketch, everything is carrying the eye into the heart of the painting.

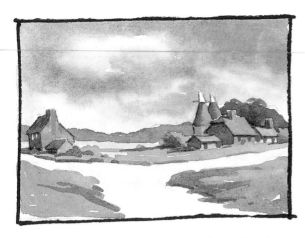 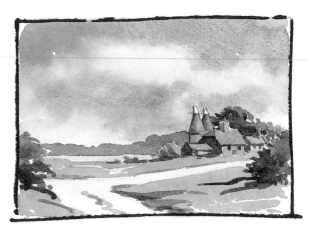

5 How, then, to keep the viewer's eye firmly on your painting and to direct it in such a way that it comes to rest at the centre of interest? In the left-hand sketch, the forking lane carries the eye first to the left, then to the right and provides no resting place. This is because there are two competing centres of interest.

In the solution to the problem, we have concentrated on one of these – the group of farm buildings to the right – and eliminated the other. By the use of carefully placed trees and bushes we have also blocked off both lanes so that they do not carry the eye off the edge.

 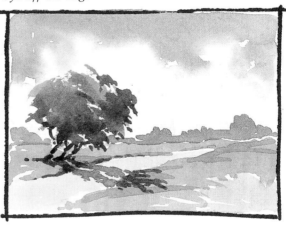

6 While on the subject of lanes and roadways, it is worth noting that they can present problems of their own. For one thing we want to avoid the common fault of making them appear too dominant. For another we want to avoid our road margins

originating in the very corner of the paper. It is sometimes useful to break up their length by including lateral shadows, and these, if correctly painted, will help to describe the contours of the ground over which they fall.

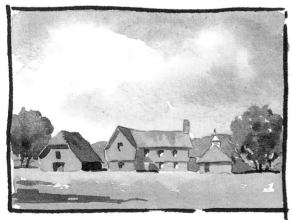 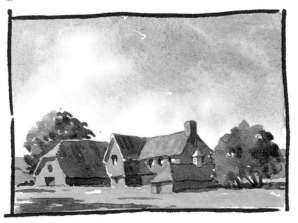

7 One of the ways to achieve good composition is through the careful grouping of the features of the chosen subject. It is clearly better to adopt a viewpoint from which there is some overlapping rather than one from which the objects appear to be

strung out in a straight line, without any connecting link. For much the same reason a building observed head on is usually a less interesting shape and of less artistic appeal than when viewed more obliquely.

19

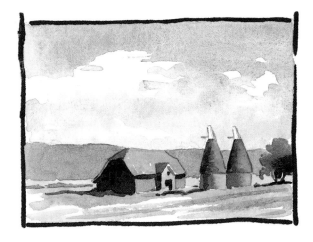 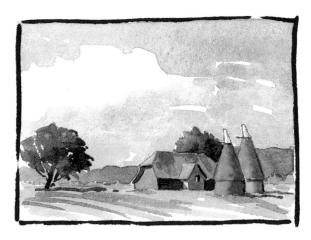

8 We have all seen paintings in which unrelated lines appear to coincide. In the left-hand sketch the line of distant hills continues the line of the cottage roof, while the two oasthouses appear to be touching instead of overlapping. These two basic faults are corrected in the right-hand sketch.

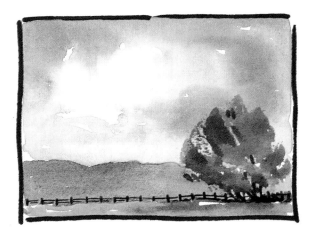 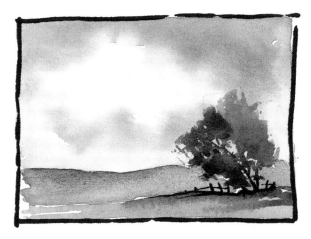

9 Problems arise when too much unnecessary detail is included. This makes for an over-busy painting for which a little simplification would work wonders. For example, the inclusion of a long line of regular fencing is usually fatal to good composition, and a shorter line, consisting of a few random posts, is infinitely preferable from the artistic if not from the utilitarian viewpoint.

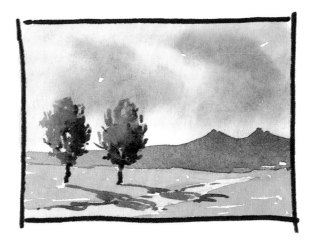

10 A mistake which often crops up is that of making objects in a painting appear too similar. This can arise when a painter studies the first object with some care but is then content to copy what he has already drawn for the second. If the objects in question are very similar in size, shape and tone, you should try hard to spot what differences there are and to make the most of them. Note how the repetitive forms in the left-hand sketch have been varied in the corrected version.

Not all subjects, however attractive, make good compositions. If shifting your position to find a better viewpoint does not do the trick, then as we have seen above it may be necessary to modify certain parts of the scene before you. Opinions differ on the ethics of adopting this rather drastic course, and much depends upon the object of the painting. If, to cite an extreme example, you have received a commission to make a painting of someone's house, then obviously you cannot play fast and loose with the local topography. If, on the other hand, the exact arrangement of the subject matter has no particular significance, there can be no real objection to a little judicious rearrangement if it enables you to achieve a better composition.

There is a lot to remember in this business of composition, but with growing experience, much of it becomes instinctive.

In the context of art, tone simply means lightness or darkness: light objects are said to have high tone, dark ones low tone. It is vitally important to get your tone values right. If, for example, you use your darkest colours for passages in your painting that are not at the bottom of the tonal scale, then you have nothing in reserve for still darker areas. If your judgement of tone is at all suspect, you would be well advised to work out your tone values in a preliminary black-and-white sketch, using conté or charcoal, and this would have the added advantage of helping you with your composition. When tone values are correct, a painting will stand up to being photographed in black and white and will still look convincing.

To some extent tone evaluation must be a compromise. We have nothing in our palette to match brilliant sunshine and any attempt to paint the deepest shadows as they really are would push the watercolour medium beyond the limit. In absolute terms, then, the tones we use are a compromise, but they should still be relatively correct.

Inexperienced painters often portray trees and green fields as though they were very similar in tone. Trees are, in fact, almost always darker, for their form is such that much of their foliage is in shadow whereas fields are flat and reflect far more light from the sky above. In addition, trees are often viewed against a bright sky and this makes them appear even darker than they are. Finally, tree foliage is normally deeper in tone than grass. So when you are painting in the field, be on the look-out for these tonal differences and do them full justice in your painting.

(overleaf)
The Church on the Marshes (10¾in × 15½in)
This lonely but much painted little church makes an appealing subject for the watercolourist. With no buildings or other prominent features nearby to provide balance, it poses certain compositional problems, so it was decided to place it left of centre and balance it with the stands of trees and heavy cloud shadow on the right. A very low horizon was adopted, a useful ploy with marshland subjects, for their very flatness seems to emphasise the immensity of the sky above. The weather was threatening and despite occasional gleams of pale sunlight, rain was never very far away, another good reason for working quickly! The foreground drainage ditch leads the eye conveniently to the church on its little green island and the lines of trees and hedges do much the same.

The light-toned sunlit elevation of the church made an interesting contrast with the slate-coloured clouds behind and its shadowed side with a paler patch of sky to the right, so this dramatic effect was emphasised. The sky was painted quickly and boldly, with deep shadows giving form and shape to the clouds. The foreshortening of the distant fields underlines the flatness of the terrain while the greying of the distant trees suggests recession and contrasts with the warmer colours of the nearer copse.

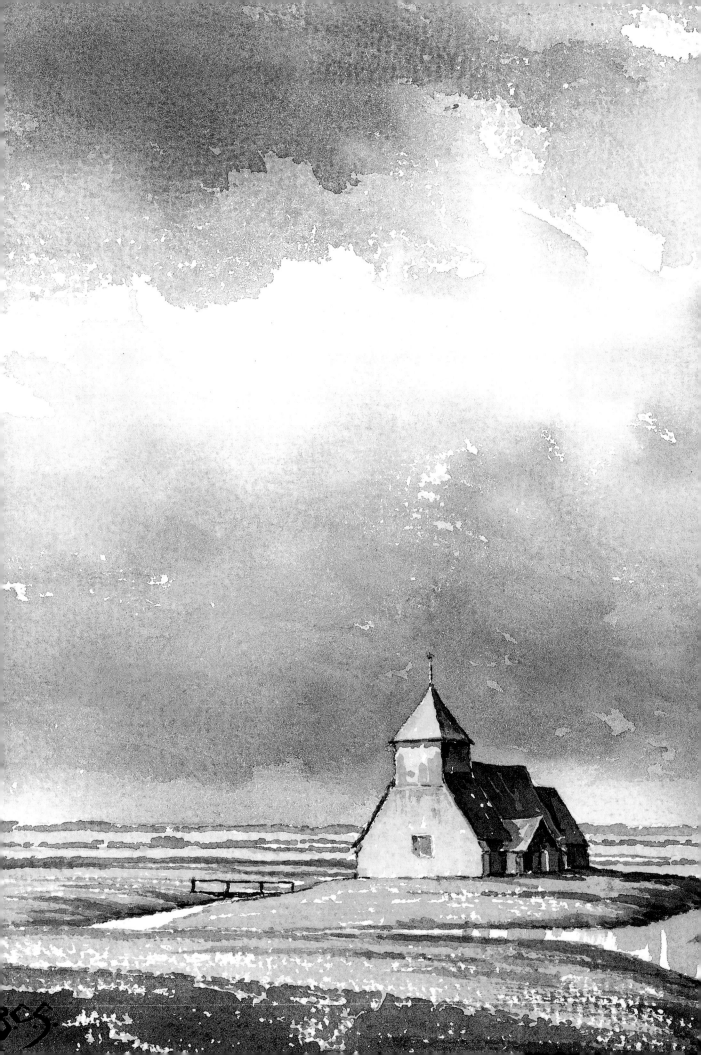

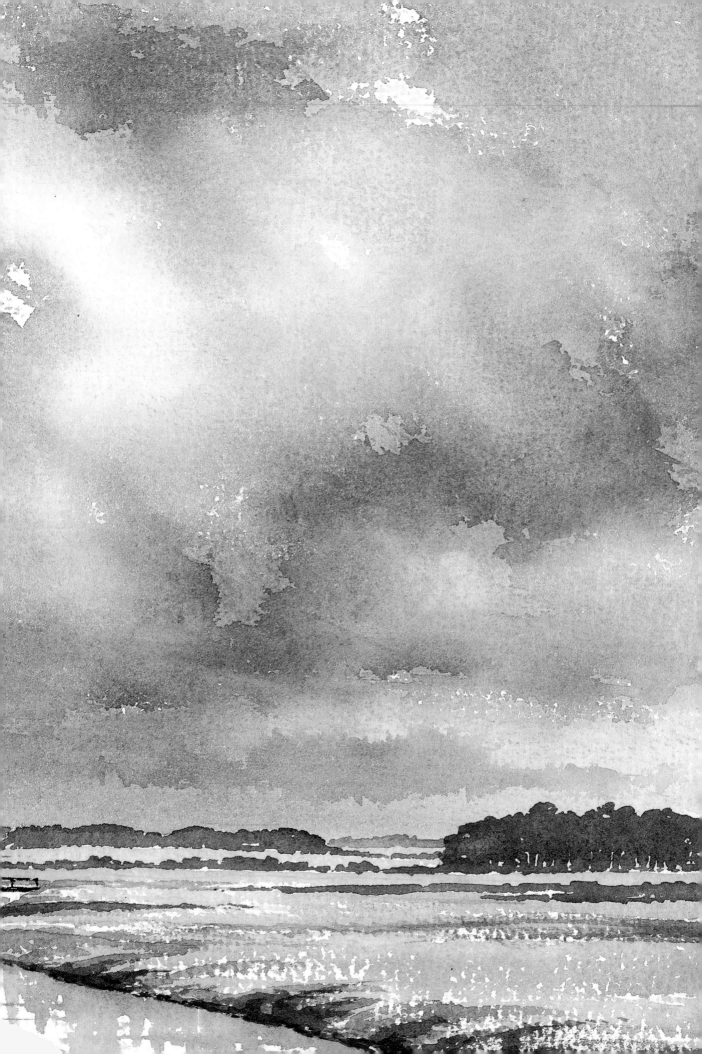

3
Perspective Made Easy

The title of this section may seem a little presumptuous to those who find perspective a real problem, but the truth is that once the comparatively simple rules are understood, everything falls into place and the problem really does disappear. So for the moment take this assurance on trust and read what follows believing that you, too, can master perspective. And once you have, it is like riding a bike, you will not forget it.

Perspective all depends upon the self-evident proposition that the further away an object is, the smaller it appears. That is not difficult to accept, is it? This obvious truth, then, can be represented diagrammatically by a straight line of telegraph poles of equal height stretching away on a flat plain to the far horizon (fig 1).

There are several points to note here. First, because we are postulating a dead-level plain, the horizon coincides with our eye-level line. In practice, this only happens with a sea horizon, for hills and trees and so on break the land horizon. Second, if we draw a line joining the top of the poles and another joining the base of the poles, these lines meet on our eye-level line, at a point where the poles are so distant we can no longer see them. This is called the vanishing point. Third, the line joining the points below eye level slopes up to the vanishing point while that joining the points above eye level slopes down to it. Nothing very hard so far! Let us now apply all this to a solid object, such as a flat-roofed house, viewed obliquely (fig 2).

If we extend the lines representing the tops and bottoms of the two side walls, they, too, will meet on our eye-level line, and this provides a simple way of checking up on the correctness of our perspective drawing. Two points to note here: first, the lines above eye level slope down to the horizon, those below eye level slope up to it. Just as before. Second, the lines of that side of the house turned towards us slope gently to the vanishing point, while those of the side turned away from us slope much more steeply.

You may feel all this is very simplified and that in the real world shapes are far more complex. True, but even complicated shapes can be broken down into simple ones and the principles hold good. Now let us consider a building all of which is above our eye level (fig 3).

Here the lines representing the tops of the walls and those representing the bottoms of the walls all slope down to the horizon, just as we would expect. Note also that the lines of the tops and the bottoms of doors and windows follow the same rules. Now let us take the example of a curved road, with houses built on that curve, and see what happens (fig 4).

Again, the lines representing the tops and bottoms of the house fronts meet on the eye-level line, but all at different vanishing points. Notice how the gradients of these lines vary, the steepest being those of the houses on the left which are more obliquely placed. Notice, too, how the lines of the right-hand house, which is directly facing us, are parallel and so do not meet at all.

Many people have difficulty with the perspective of buildings situated on hills, so let us imagine such a situation (fig 5).

The same principle still applies and the continuation of the lines representing the tops and bottoms of the houses still meet on the eye-level line, which here coincides with the observed horizon as we are looking out to sea. Because of the steepness of the hill down to the harbour, these houses have to be built up on the right to provide a level base. In the example I have taken, the houses are all parallel so there is only one vanishing point. If they had been set at different angles there would, of course, have been several vanishing points, just as there were with the houses built on a curving road, which we considered earlier.

Just one more point to consider: the closer a building is to you, the steeper will be the lines sloping to the vanishing points. The converse is also true: the further away a building is, the flatter those lines will be. It is all a matter of the *relative* distances from the eye to the nearer and further corners of the house.

The perspective of shadows is a rather more complex matter and the geometric construction correspondingly complicated. To avoid confu-

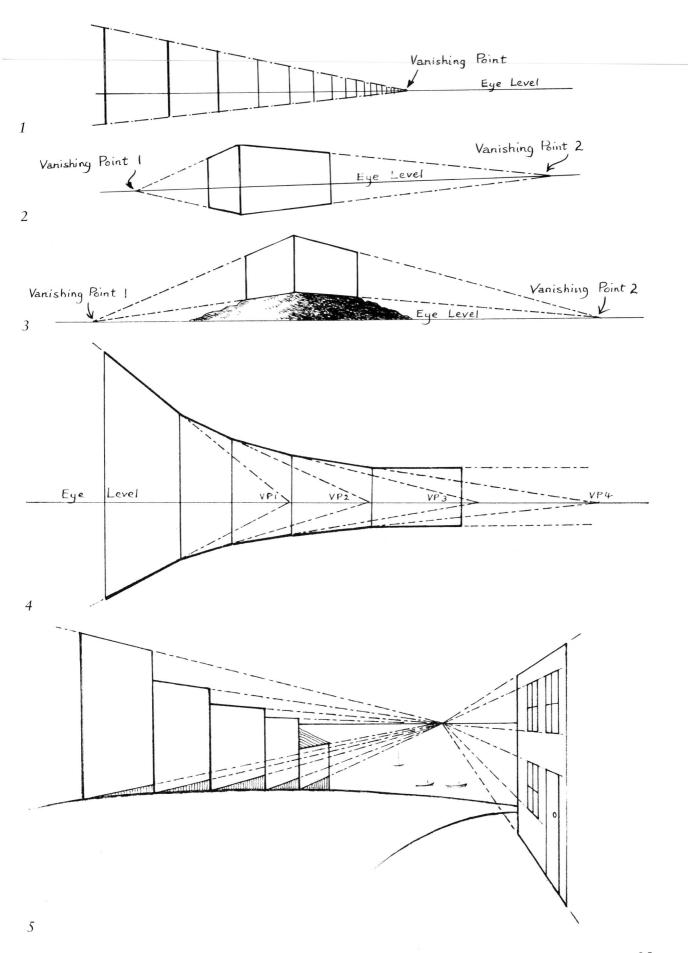

1

Vanishing Point

Eye Level

2

Vanishing Point 1

Vanishing Point 2

Eye Level

3

Vanishing Point 1

Vanishing Point 2

Eye Level

4

Eye Level

VP1 VP2 VP3 VP4

5

6

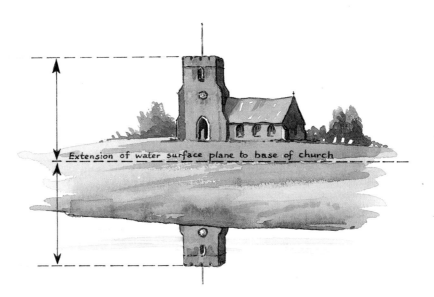

7

Water Line

8

Extension of water surface plane to base of church

sion, therefore, I suggest that you rely on observation to construct reasonably accurate shadows. The perspective of reflections in water needs care for these can look very odd if not drawn accurately. To take a simple case first, a row of buildings rising from the water's edge presents no problems; they simply appear in their entirety, upside down (fig 6).

The same principle holds good with a more oblique arrangement, and all we have to do is to measure the height of key features above the water line and measure off an exactly equal distance below it. This construction will provide a framework upon which to base your drawing. The sketch of the old stone bridge shows how this is done (fig 7).

A building or other object set back from the water's edge is another matter and we need to understand the construction to be sure of showing just the right amount of reflection. Here is an example (fig 8).

In your imagination extend the plane of the water surface so that it cuts right through the riverbank to a point directly under the building, in this case a church. This imaginary extension of the water surface is represented by the dotted line AB. We now measure the distance from the top of the church tower to this line, and this distance, measured from the line AB down to the river, shows just how much of the tower will be reflected. Because the river bank is sloping back, it is not reflected; if it had been more vertical, there would have been some reflection.

Cretan Village (10in × 13¼in)

A simple little painting of an almost deserted village street in which the constructions described may be used to check the perspective. Notice how the lines above eye level slope down to the imaginary horizon, and those below slope up to it.

In the matter of composition, the buildings on the left prevent the curving road carrying the eye off the painting while the shadows they cast serve to break up what would otherwise have been an excessive area of road.

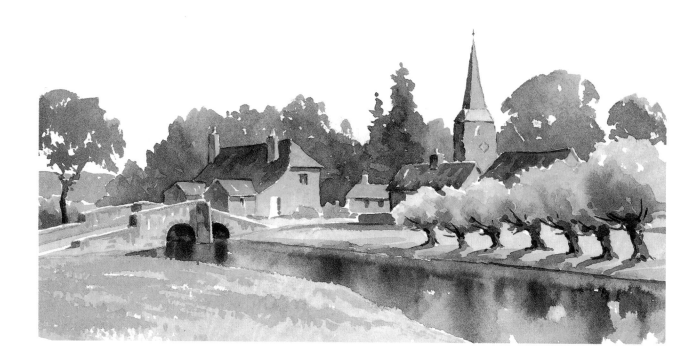

Not all perspective problems can be solved by geometric means, and with these we have to rely on careful observation. A winding river flowing through a broad valley is a case in point. Incorrectly drawn, the river may appear to be flowing uphill. Another very common fault is that of exaggerating the vertical depth of distant fields, which makes them look much closer than they are.

With experience perspective becomes second nature but until that happy day it is a good plan to check your drawing with one or other of the simple constructions described. At this point it is worth noting that perspective can be deliberately distorted to gain dramatic impact, but this is a ploy that should be used with discretion.

Another aspect of the subject is aerial perspective. This concept depends upon the observable fact that the further away an object is, the more the intervening atmosphere will modify its appearance. The mistier the conditions, the more noticeable this effect will be. Colours will become softer and tinged with blue and grey and there will be less tonal contrast between lights and darks. Both these effects will give the object in question a feeling of recession. Soft greys, blues and mauves are therefore recessionary colours while bright yellows, oranges and reds bring objects forward. I remember a student of mine once including a distant field of rape seed in his landscape painting. Even at a distance, the brilliant yellow of this crop was virtually undimmed, and this is how he painted it, thereby destroying any feeling of recession. We sometimes have to ignore what is there and make the landscape behave as we want it to!

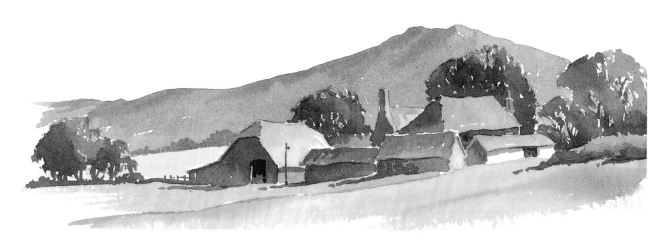

Burnham Overy Staithe (12¾in × 17½in)
*In this Norfolk scene, the lines of the main building –
a ship's chandlers – obey the rules of perspective and
also point to the bend in the river which here
constitutes the centre of interest. The lines of the river
are such that the water appears to 'lie flat' and the
dark bank prevents the river carrying the eye off the
painting to the left. The distant line of trees are blue/
grey in colour, to aid recession, and everywhere in the
painting there is counterchange – the setting of lights
against darks and darks against lights – to provide
strong tonal contrast.*

(overleaf)
Blakeney Marsh (10½in × 19in)
*Once again the perspective of the river ensures the
water lies flat and the greying of the long line of trees,
paling as it becomes more distant, strongly suggests
recession. The pale, grey-green area of marshland
beyond the river and its cloud shadows are
foreshortened in a vertical plane, to reinforce the
impression of flatness. The low horizon enables a
lively sky to be given due prominence.*

29

4
The Tools of the Trade

Bad workmen are said to blame their tools, but bad tools make good work more difficult, and this is particularly true in the field of art. Poor or badly chosen materials present almost insuperable, though quite unnecessary, problems. The enormous and ever-growing range and the extravagant claims advanced by some manufacturers make the task of selection a difficult one. The high cost of some materials makes it even more important to choose wisely and cut out inessentials, and here the watercolourist is fortunate in that his requirements are comparatively simple. In this chapter we shall consider these requirements in some detail and make recommendations which will help you select what you really need, for the least expense.

Paint-box and tubes of paint

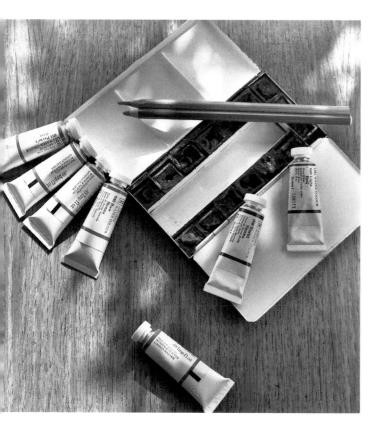

Paints

The first purchase made by the aspiring watercolourist is usually a paintbox and the retailer has an interest in selling an expensive one, with a bewildering array of colours. The beginner may then feel he is not using this expensive purchase to the best advantage unless he uses the full range of colours in each painting. This is an expensive mistake and it is far better to choose a compact box with no more than a dozen colours. There are two advantages in adopting what is known as a limited palette: first, colours vary considerably in strength and in their handling properties; if you confine yourself to, say, half a dozen, you get to know these properties well and this is bound to benefit your technique. The second advantage is that by using a small number of colours, your paintings will 'hang together' more effectively, a theme that is covered more fully in Chapter 5.

There are two main grades of watercolour paint, students' quality and artists' quality. Artists' quality paints have greater strength and clarity, with more finely ground pigment and are naturally more expensive. Whether this additional cost is justified must be a matter of personal judgment, but it is worth bearing in mind that the difference in cost per painting must be small while the difference in brilliance and freshness may be appreciable.

Our next consideration concerns the relative merits of pan and tube colours. Pans are certainly more convenient to use, but as the paint is exposed to the air, it tends to dry and it is frustrating, as well as harmful to brushes, to try to coax reluctant pigment from dried-up pans. On the other hand, squeezing out large dobs of tube paint round the margin of the mixing palette can be very wasteful as perfectly good paint is washed off at the end of the day's work. The best answer to the problem is to squeeze out fresh paint from the tube into the appropriate pan at the beginning of each painting session, for in this way you will always have fresh, plastic paint at your disposal. What is more, the fresh paint will liven up what is already there in the pan, and nothing is wasted.

Brushes

We should think carefully about the brushes we buy for they are bound to influence our work for good or ill. Without doubt the best watercolour brushes are those made of kolinsky red sable and these are a joy to use, but the fact has to be faced that today they are extremely expensive. Fortunately there are alternatives and some of these are very good, particularly those with a mixture of sable and manmade fibre. The sable constituent enables them to hold good, full washes, while the manmade fibre gives them good spring and shape, and they are only a fraction of the cost of pure sable brushes.

The number and size of brushes required will depend to some extent upon the scale and style of your work. Generally speaking it is useful to have at least two large flat brushes, a 1in and a ½in, and a variety of smaller round brushes, perhaps a 12, a 10, an 8, a 4 and a rigger. It is good practice to use as large a brush as you can for this helps you to achieve broad, clear washes and eliminates fussy detail. Care of brushes is an important matter and will greatly prolong their useful life. After use they should be carefully washed in clear water until all trace of pigment has been removed and then laid flat and allowed to dry in the open. All too often, painters place wet brushes in jars immediately after washing, causing the remaining moisture to run down into the ferrule, to the detriment of the base of the hairs. Placing damp brushes in closed boxes is another bad habit for if they remain damp too long mildew and rot may well cause damage. A bristle brush can be a useful addition for removing unwanted paint from the watercolour paper, though it has to be said that only the more robust surfaces will take such treatment without serious damage.

Papers

There are many different kinds of watercolour paper on sale, varying enormously in quality, in weight and in type of surface and there is surely something to suit every style and taste. It is important for the success of your work to find one that really suits you and enhances your work, so it is well worth experimenting until you locate your ideal.

Papers vary in weight, usually from 90lb to 300lb to the ream (480 pages of Imperial size). The advantage of the heavier papers (200lb and above) is that they do not cockle seriously even when full washes are applied to them. When cockling occurs the liquid paint collects in the hollows, causing uneven washes, uneven drying and other horrors. Of course the heavier papers are more expensive, and if you prefer to use the

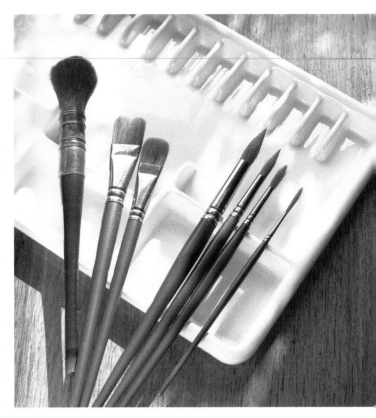

Brushes and mixing palette

Sitting at the easel

33

Standing at the easel

Drawing board on lap

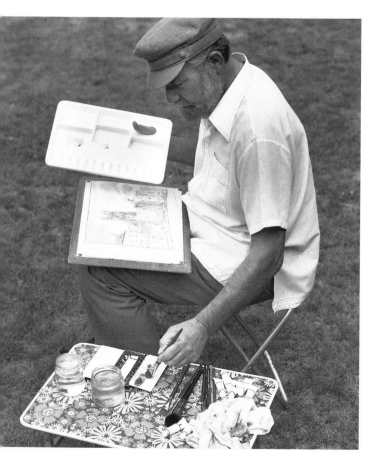

lighter variety, you should stretch them. This is done by immersing the sheet for about half a minute in clean water and laying it flat on your drawing board. The excess liquid and any air bubbles are removed with a soft rag, care being taken not to damage the surface of the paper, which is very vulnerable when wet. The edge of the paper is then stuck down firmly all round with brown, gummed tape (*not* masking tape) and the board stood on its side to dry, slowly and without the application of heat. The following day the paper should be flat, taut and may be used without fear of cockling. There is one slight disadvantage, apart from the tedium of the process itself, and that is the removal of some of the surface dressing by soaking, for this some-times makes it more difficult to achieve sparkle in the subsequent painting.

There are three principal types of surface in watercolour paper: 'smooth' (or HP for hot pressed); 'Not' (or CP for cold pressed) and 'rough'. The smooth surface contains very little 'tooth' and is not suitable for most styles of watercolour painting. At the other extreme, rough has a pronounced grain and is useful for obtaining textured effects and for dry brush work. It also gives rise to granulation, when the pigment collects in the little hollows of the surface to produce a somewhat speckled effect, which can sometimes be employed with advantage to repre-sent texture. Between the two extremes is the Not surface, which is a good compromise and suitable for most purposes.

Other Equipment

For work in the field, robustness combined with lightness should be the aim. It is unlikely that your paintbox will provide sufficient space for all the washes required so you will need a mixing palette as well. There are a number of excellent designs on the market which provide ample space and enough divisions to keep washes from runn-ing together unintentionally. The lighter mixing palettes are of plastic and the better quality resist staining surprisingly well.

A drawing board large enough to take your normal paper size is, of course, a must. You will need a light folding stool if you prefer to sit while you work and a light, but sturdy, easel unless you paint, as I often do, with board on lap. If you employ full, liquid washes, it is sometimes useful to be able to tilt your board in various directions and enlist the aid of gravity to achieve the effects you want. A low folding table, conveniently placed, can be handy for taking paintbox, water jars, brushes, spare tubes and so on. Plenty of clean water is vital for a meagre supply that has

become muddy makes clear, fresh work an impossibility. It is a good plan to use two jars, one for washing brushes, one for mixing with paint. Do not forget to include clean rags or tissues.

If you like to make preliminary sketches to help you decide the best angle from which to view your subject, and perhaps work out your tone values in advance, you will also need a sketch block, pencils of varying blackness, perhaps a stick of charcoal and a rubber. With growing experience you may well wish to vary this list. There are all sorts of additional aids which you may care to consider. A putty rubber is well worth including for it will do less damage to the surface of your watercolour paper than the india-rubber variety. A sharp knife, or razor blade, used with restraint, can sometimes be useful for producing crisp light accents, masking fluid can preserve small areas of white paper and masking tape larger ones. Care should be taken to ensure these masking aids do not, on removal, take fibres of paper with them. Finally you will need something in which to carry all your equipment and tough army surplus haversacks are particularly suitable for this purpose.

Many beginners are reluctant to paint in the open for fear of someone looking over their shoulder; such reluctance is understandable but misplaced. To many members of the general public, even painting of modest standard is as magic. With growing experience, timidity disappears, particularly if you join an art club and paint with a group, finding safety in numbers. If you habitually paint indoors, you miss those little quirks of nature and tricks of the light which bring life and immediacy to your work and the more comfortable and controlled working conditions of the studio can never make up for this. So take your courage in both hands and accept gratefully what nature has to offer.

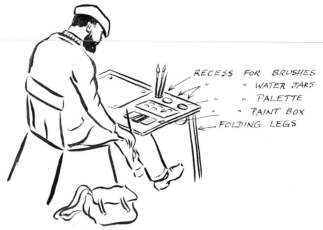

RECESS FOR BRUSHES
" " WATER JARS
" " PALETTE
" " PAINT BOX
FOLDING LEGS

A home-made solution

(overleaf)
Rye Mill (10½in × 14½in)
This is an example of a painting on a Not paper. The surface is sufficiently rough to respond to dragged-brush work, as you will see from the outlines of the trees and the foreground reeds.

The sky was painted first with two full washes, the first of raw sienna with a little light red, the second of ultramarine and light red. A 1in flat brush was used for each of these washes, which were allowed to blend at the margin. Too much work with the brush would have caused excessive mixing and blending to take place to the detriment of the area of radiance above the horizon.

This broad treatment of skies, with large, well-loaded brushes, makes it impossible to paint carefully round such features as the old mill, so masking fluid was used to pick out its sunlit sails, railings and other details. Remember to test masking fluid on an off-cut before using it on your watercolour paper to make sure it will not damage the surface.

Notice how the soft greys of the distance help it to recede while the warmer colours of the nearer features, with their stronger tonal contrast, bring them forward. Notice, too, how the soft treatment of the reflections in the water complement the detail above and do not compete with it.

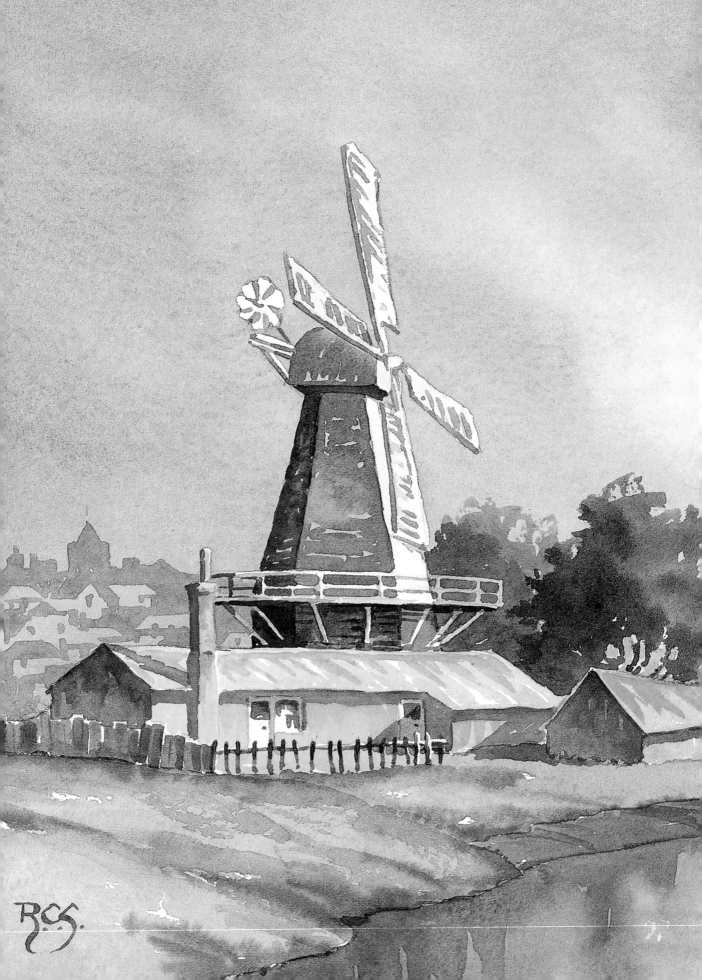

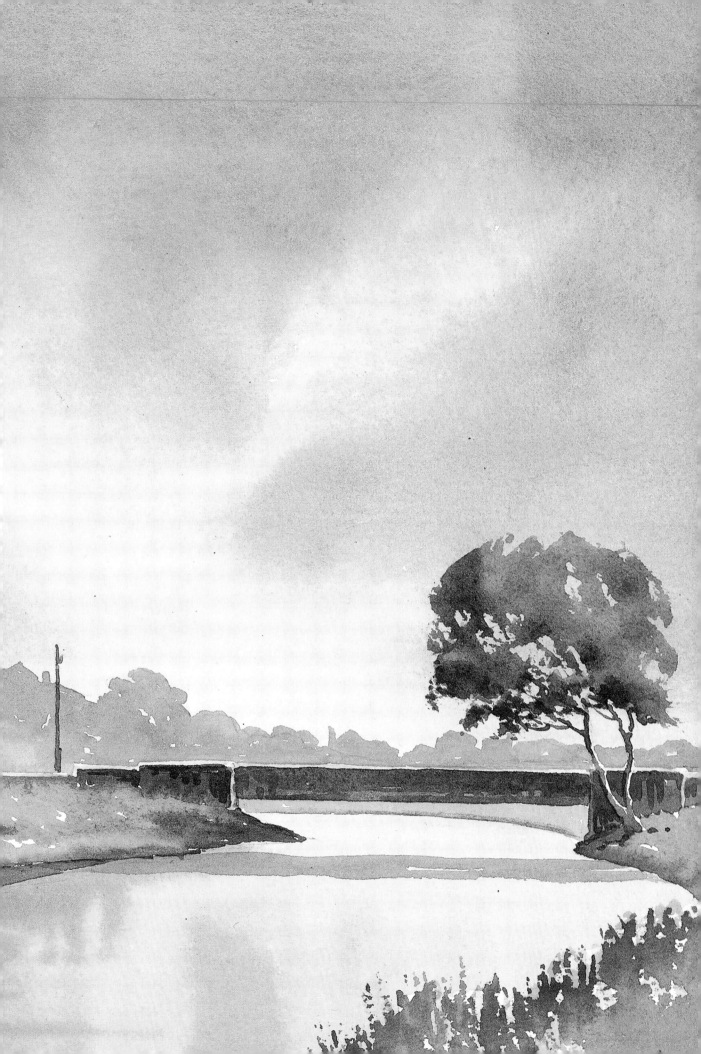

(above)
The River Dart (10¾in × 14½in)
Here a rough-surfaced paper was used and its roughness exploited to achieve a broken outline for the trees and a suggestion of sparkle on the water. Once again a soft grey was used for the distance, to make the shoulder of moorland recede, and warmer colour employed for the nearer features. There is plenty of tonal contrast in the foreground, notably between the bleached shingle in the lower left corner of the painting and the rich browns of the tree reflections above. The colours used were raw and burnt sienna, ultramarine, Winsor blue and light red.

5
Make Your Colours Glow

Pure watercolour is essentially a transparent medium, at its best when the paper is allowed to shine through to impart a beautiful freshness and clarity to the wash. This attractive freshness progressively decreases as additional washes are added and eventually dullness and muddiness make their unwelcome appearance. It is for this reason that watercolour students are always enjoined to say what they have to say in as few washes as possible – ideally in one! Another sound piece of advice is to apply colour in full, liquid washes, for colour applied with a sticky, rather dry brush never has the same clarity.

The expression 'dry brush' applied to a technique for obtaining a textured effect is something of a misnomer and is responsible for much dull work. For the best effects the brush should hold a limited amount of fairly liquid paint so that a quick stroke across the surface of a Not or rough paper will deposit colour on the little hills but leave the little depressions untouched, producing a speckled or textured effect. Because the colour is applied in fairly liquid form, it will be clear and transparent on drying, not dull and opaque as it would be if applied with too dry a brush. It takes forethought and planning to produce paintings of freshness and clarity but it is worth the effort.

As the beauty of watercolour lies in its transparency, the use of body colour should be avoided. True, there are many artists who produce splendid results with the help of opaque colour but there is a chalkiness about Chinese white highlights which cannot match the clarity of untouched paper.

In Chapter 4, the advantages of the limited palette were considered; the question now arises as to which colours to choose from the enormous number available. There are almost as many opinions on this subject as there are artists and their work is recognised not least by their characteristic palettes. To begin with, garish colours should be avoided for watercolour is at

its best when it understates. This means that the colours actually seen in nature sometimes have to be toned down to achieve a harmonious result. To cite an extreme example, if you were to try to match the brilliant blue of an overhead Mediterranean sky, pure, strong ultramarine would probably be used, and yet in practice this would look impossibly harsh. It would, therefore, be advisable to tone it down a little with, perhaps, a touch of light red and rather more water. Postcards from friends holidaying in overseas sunspots usually show skies of eye-aching blue and even though the colour may be true to life, it looks altogether too strong on such a small scale. Of course choice of colours must necessarily be influenced to some extent by subject matter. In flower painting, for example, the palette would have to contain colours capable of doing justice to the brilliant reds, purples, mauves, blues, pinks, oranges and yellows that abound in the florist's window.

My own basic palette consists of raw sienna, burnt sienna, light red, ultramarine, Winsor blue and Payne's grey, though I sometimes add to this for particular purposes. You will notice there is no green in my list. This is because, like many painters, I prefer to mix my own. Raw sienna, with a touch of Winsor blue, produces a splendid green for sunlit grass. If a still brighter green is required, perhaps for mown lawns or grazed fields, cadmium yellow may be substituted for, or added to, raw sienna. Raw sienna mixed with ultramarine produces a browner green, more akin to khaki, which is also useful for landscape work. Inexperienced painters often use made-up greens with far too much blue in them for foliage and this imparts an unreal look to their work. For those who prefer a made-up green, olive green is a good colour for foliage, though even that can usually benefit from an additional touch of yellow.

One of the painter's perennial problems is how to represent convincingly areas of glowing colour in the landscape. How can he, for example, paint a field of sunlit corn so that it really does appear to shine? There is only one solution to this problem and that is to place some darks alongside so that, by contrast, the passage in question appears luminous. If the corn is seen against a dark bank of trees or a cloud-shadowed hillside, this can create the illusion of sunlight. A similar tactic can be used to emphasise the colour of a particular passage, though in this case complementary colour rather than tonal contrast is employed. Complementary colours are, quite simply, opposites, for example red and green or blue and yellow. To emphasise the colour of a red

pantiled roof, surround it with a mass of foliage, the green of which will heighten the impact of the red. The use of complementary colour to add emphasis is a technique widely employed by painters throughout the ages and is at its most effective when used with subtlety and restraint.

The most successful paintings are often those in which there is an imaginative use of colour and in which the artist has consciously sought, and found, colours above and beyond the obvious ones. A landscape in which the painter has simply reproduced uncritically the predominant greens of the countryside before him is unlikely to strike a chord or evoke much response. If, on the other hand, he has sought, and discovered, colours other than green, and has introduced and, perhaps, even exaggerated, the hints of red, orange, brown and purple that abound in the landscape, then his work will come to life. This has nothing to do with the approach of some painters who deliberately set out to distort colour by painting trees vermilion and grass ultramarine, to create a surrealist dream world of their own. So train yourself to look beyond the obvious and by studying your subject matter with imagination and insight, find colours that will breathe life into your work.

The sketches opposite show how a limited palette may be used to produce a range of colours suitable for landscape work.

Mix no 1
Here raw sienna and a little Winsor blue have been mixed to obtain a grass green. The darker green of the line of trees was put in to provide tonal contrast.

Mix no 2
The warm, dark green of the trees is a stronger blend of raw sienna, burnt sienna and Winsor blue, with a mixture of ultramarine and light red added for the shadowed areas.

Mix no 3
Light red with a little raw sienna makes a good terracotta colour for tiles. A touch of green was added to provide variety and suggest algae.

Mix no 4
Light red and ultramarine in varying proportions, produce a wide range of warm and cool greys, with a hint of purple. A strong wash, with a preponderance of light red, is used here for shadowed brickwork and tiles.

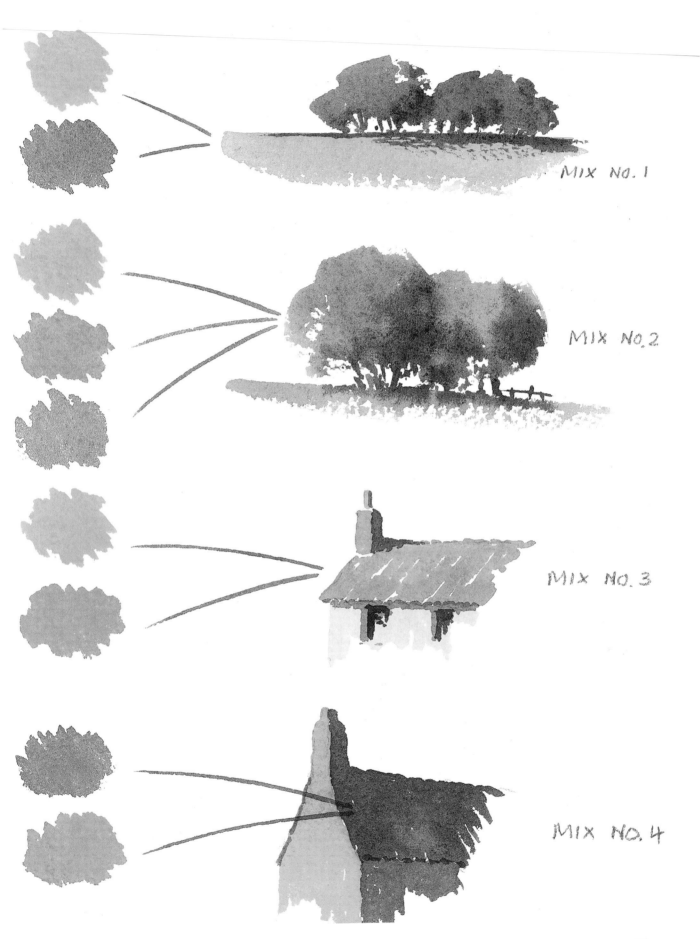

MIX No. 1

MIX No. 2

MIX No. 3

MIX No. 4

Beechwood (10¾in × 14⅝in)

Colour plays an important part in this painting. The sunlit foliage was raw sienna with just a touch of Winsor blue, the proportion of blue being increased a little for the leaves in partial shade. The more distant trees were in full shade, so still more Winsor blue was added and this was blended with a second wash of ultramarine and light red, which, much diluted, also served for the line of distant hills. The progressive 'greying' of the more distant features conveys a strong feeling of recession.

The ground, covered in dead leaves and beech mast, was indicated with a broken wash of burnt sienna, varied here and there with touches of green while the tree shadows falling over it were put in with bold washes and broken lines of ultramarine and light red. The tiny figure, strategically placed in a gap in the trees, was put in with pure light red and makes a crisp accent against the complementary green of the foliage.

(facing above)

Farmhouse, Buckland in the Moor (11in × 16⅜in)

There was a marked contrast in colour and tone between the sunlit and shadowed facets of the granite walls of these old farm buildings. A very pale wash of raw and burnt sienna with just a touch of ultramarine served for the sunlit areas and a few of the massive blocks of stone were added in various shades when the initial wash was dry. The shadowed walls were mainly ultramarine and light red, but this wash was modified here and there with raw sienna, light red and, closer to the ground, green. A few random blocks of granite were added with the same grey used for the weather-staining on the chimney stacks.

The grass was raw sienna with a little Winsor blue and a stronger wash of the same colour, plus a touch of burnt sienna, was used for the trees. The distant bank of trees on the right was put in with a wash of ultramarine and light red to which a little green was added while it was still wet. The same five basic landscape colours were used for this painting though a little alizarin crimson was added for the border flowers in front of the farmhouse.

(facing below)

The Bridge at Chioggia (10½in × 14¾in)

This painting of a canal near Venice reflects the warm light of early evening which makes the ochre and terracotta washes of the buildings glow. The colours used were various mixes of raw and burnt sienna and light red. There is rich colour, too, in the shadows and warm, reflected light can be seen in the buildings just above the bridge. Ultramarine was added for the more distant buildings to suggest recession. The colours of the buildings reappear more softly in the liquid rendering of the reflections.

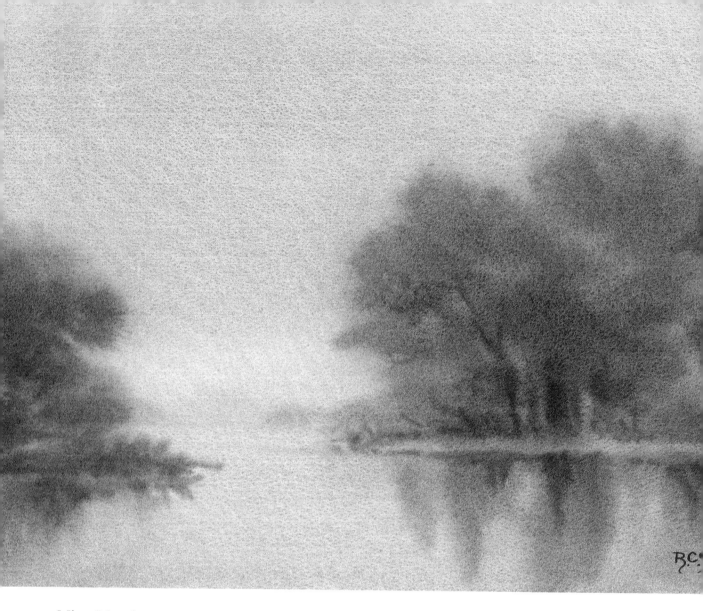

Misty Morning (11¼in × 14⅝in)

This painting illustrates two of the techniques described in Chapter 6: the variegated wash and the wet-in-wet method of painting. The outlines of the trees and banks were softened by the mist rising from the river, so hard edges would have been out of place. Speed is of the essence in a painting of this sort, for everything has to be put in before the initial wash dries to ensure a soft-edged effect – a matter of about twelve minutes in this case.

First of all, two generous washes were prepared, one of Winsor blue plus a little raw sienna, the other of pure, weak raw sienna. These were applied in horizontal sweeps of a 1in flat brush, starting at the top with the blue wash. About a quarter of the way down, the brush was dipped in the yellow wash and so a gentle gradation of colour occurred though, as planned, traces of blue still persisted. About three-quarters of the way down the process was reversed, and the brush again dipped in the blue wash.

The next problem was to indicate the broad masses of the trees, the banks and the reflections, in various combinations of raw sienna, burnt sienna and Winsor blue. By the time they were prepared, the graded wash was dry enough to receive them. In liquid washes of this sort some colour separation often occurs and the siennas bled slightly into the background wash to provide the desired halo effect. A slightly stronger wash of ultramarine and light red was used to suggest the soft areas of shadow and as still more drying had occurred, this spread rather less. An even stronger mix of these two colours was used for the tree-trunks and other dark areas. Because the graded wash had dried more and the mix was a stiff one, very little spreading occurred, but the dark accents remained soft-edged.

The success or otherwise of a painting of this type depends entirely upon correct judgment of the speed of drying.

6
Fresh Watercolour Techniques

Before we get down to the actual business of painting, there are two matters which need our careful attention. One of these concerns the angle at which our painting board should be tilted during the painting process. As with so much in watercolour, there are no hard-and-fast rules and the only yardstick is personal preference – in other words, work at the angle that suits you best. If the board is too upright, full washes are hard to control and tend to stream down the paper; if it is flat, the washes do not flow at all and tend to gather in puddles. A good compromise is about 15 degrees from the horizontal, for at this angle gravity exerts just enough, but not too much, influence. This gravitational effect which causes the washes to flow slowly down the paper, is particularly useful in the painting of skies, a topic dealt with later in the book.

The second point to be considered is the speed of drying of paint on paper, for an understanding of the drying process is vital to successful watercolour work. This is a far more complex matter than it sounds for drying time is influenced by all manner of things. Obviously, washes will dry far more quickly when the weather is hot and breezy than they will when it is still and humid, and extremes of this sort can add greatly to the painter's problems. In quick-drying conditions more water should be mixed with the paint to allow for quicker evaporation and washes should be applied even more quickly for, if they start to dry before they are completed, all sorts of difficulties can arise. It sometimes helps to dampen the paper to slow down the drying process. In the studio a hair-drier can speed up drying but the only answer to humid conditions in the field is patience. A further complication is that richer washes dry more slowly than weak ones and some colours dry more quickly than others. With growing experience, allowance for these factors becomes automatic.

Watercolour painting is firmly based on the technique of the wash, of which there are several varieties. A wash is simply a pool of paint mixed with water and applied to the paper, the proportion of water to paint determining the strength of the resulting colour. Washes are applied when large areas have to be covered and the important point to remember here is to mix a generous quantity. If the pool of paint runs out before the wash is complete, the result is usually disastrous for not only will drying have set in before a fresh supply has been mixed, but the second wash is unlikely to match the first exactly. So prepare too much rather than too little. Another point to remember is that washes fade appreciably on drying, so make due allowance for this in their preparation. A second wash can, of course, always be applied once the first is dry, to strengthen the colour, but in watercolour painting the fewer the washes the greater the clarity of the result. If a second wash has to be used, apply it quickly and deftly, so as to avoid disturbing the underpainting.

The simplest type of wash to be considered is the flat wash. It is usually applied with a series of horizontal strokes of a large flat brush. The tilt of the board causes the paint to run down and accumulate in a bead at the bottom of each stroke, but this is taken up with the next application of the recharged brush. Large areas can be covered in this way and provided the pool of liquid paint is well mixed and applied quickly and firmly, the result should be a smooth and even area of uniform colour. With some softer and more absorbent papers, the successive brush strokes may not merge together completely and may be visible after the wash has dried. Damping the paper first may prevent, or at least lessen, this effect. If the brush is too heavily loaded, the liquid may stream down the paper and spoil the evenness of the resulting wash. It is all a matter of practice!

The second type to consider is the graded wash. In this the colour of successive brushstrokes is progressively diluted by dipping the brush in water between strokes. If well carried out the result is a smooth gradation of colour from dark to light. This technique is particularly useful for clear skies and here a pale, warm wash may be used instead of clear water. This is called a variegated wash. The procedure is to prepare two

pools of liquid colour, the first for the upper part of the sky, the second for that area just above the horizon. The first could well be ultramarine, plus a little light red, the second raw sienna, also with a touch of light red. For the first two or three strokes, the brush is dipped in the ultramarine wash but thereafter it is dipped in the second wash. As the ultramarine in the brush gradually runs out and is replaced by raw sienna, so there is a gradual transition from blue to yellow on the paper. Try to avoid washes with complicated edges for these may slow you down so much that parts of the wash may start to dry before you are ready, and then you are in trouble. If, for example, you wish to paint a complicated skyline of light-toned, sunlit buildings against a dark, slaty sky, you should consider using masking fluid for the projecting towers, spires and gables so that you do not have to paint laboriously round them and can apply your sky wash with speed and panache.

While a variegated wash is still wet, it is possible to add soft cloud effects by applying a darker, slightly less liquid wash of, perhaps, grey. Here timing is particularly crucial. If the first wash is still too wet, the second will simply disperse and be virtually lost. If, on the other hand, it is beginning to dry, then the second wash will be patchy and thoroughly unsatisfactory. If the grey wash is more liquid than the original graded wash, then run-backs will occur and ruin the painting. This unwelcome phenomenon, also known as flowering or curtaining, occurs when liquid from the second wash is carried by capillary action across the surface of the paper, and when the drying process prevents it going any further, it deposits pigment in unsightly concentrations. It is sometimes possible to use run-backs to your advantage and use them to represent, perhaps, billowing clouds, but it is a chancy and unpredictable business, calling for skill, experience and luck!

In addition to the basic flat, graded and variegated wash, there are all sorts of permutations and variations with which you will become familiar as your experience grows. Bold and effective skies may be painted by applying several washes of contrasting liquid colour. One of these might represent the areas of sunlit cloud, another the cloud shadows and a third the patches of blue sky. This technique will be dealt with more fully in Chapter 9. For the present it should simply be remembered that washes may be modified while still wet, overpainted when quite dry but should be left strictly alone while they are in the process of drying. All sorts of interesting effects may be obtained by wet-in-wet painting, which is simply

the adding of liquid colour to existing liquid washes, and these are especially useful for depicting misty and atmospheric subjects. It is sometimes useful to wet the paper first so that subsequent washes blend together to produce soft and mysterious effects. This is the exciting part of watercolour when the water often does the work for you and 'happy accidents' sometimes occur. The firmer, stronger rendering of foreground features can then provide telling contrast and enhance the feeling of recession.

We noted earlier that by concentrating on a limited number of colours, we really get to know them and their individual characteristics. One of these characteristics is a tendency to granulate, and this is possessed notably by ultramarine and to a lesser extent by some of the earth colours such as ochre and the umbers. Granulation simply means that the pigment tends to settle in the little hollows of the paper's surface to produce a grainy appearance. This property can be useful for representing a stretch of shingly beach or some other surface requiring a textured effect. Granulation is naturally more pronounced on rough-surfaced papers and it can be accentuated if the side of the board is tapped while the wash is still wet. Knowing how colours behave enables us to use their differing properties with advantage.

Some painters use tinted watercolour paper and there are undoubtedly occasions when, for instance, a warm-toned paper may exactly match the overall colour of the scene bathed in evening light. Far more often the tinted paper is not a good match and then an overall wash of a truer colour would be an improvement. A wash is also

King's College Chapel (13in × 11in)
The shining white limestone of this impressive medieval structure is a feature of the Cambridge skyline. Masking fluid was used to preserve its pinnacles and edges from the warm pearly grey of the variegated wash used for the autumnal sky (a pale mixture of raw sienna, light red and ultramarine, with a little more ultramarine towards the horizon). The sunlit tiles of the jumble of old roofs were varying mixtures of raw and burnt sienna and light red, with touches of green here and there to suggest moss and algae. A second, broken wash was applied to these tiled areas to provide texture and to indicate the slope of the roofs. The nearer trees were put in with washes of raw and burnt sienna and Winsor blue, and the more distant with a grey comprising ultramarine and light red, to suggest recession.

This famous chapel has been painted many times, but not, to my knowledge, from this angle. It often pays to spend a little time seeking an original viewpoint.

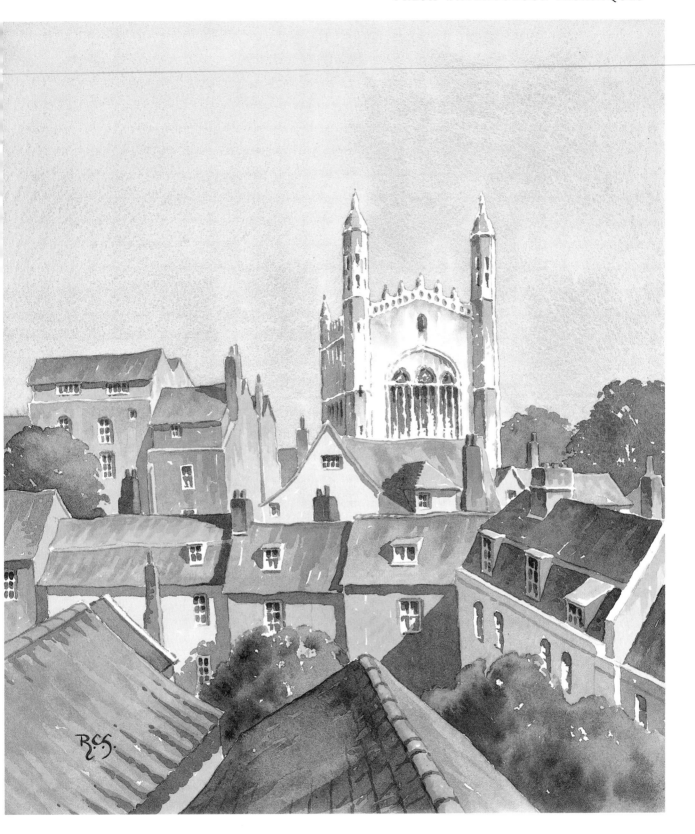

more versatile in that it can be modified to take account of local variations in the general tone and colour of the landscape. Although in broad terms it is good practice to use as few washes as possible, there are many occasions when a second, broken wash may be necessary to provide texture. Random blocks in a stone wall or weather-staining on a rendered wall are examples that spring to mind. There are a number of 'aids' to obtaining textured effects and some painters employ sprinkled salt and sand, soap, blowing straws, candle wax, leaves, fabrics and assorted ironmongery. By all means experiment with any that appeal to you, but use them with restraint and bear in mind that they are no substitute for sound painting technique.

Masking fluid and masking tape serve the useful purpose of enabling full washes to be applied without the need to paint carefully round small and intricate shapes. They can be applied both to the virgin paper and over areas already painted. Before use, always ensure that your

watercolour paper is sufficiently robust, for the dried latex can easily take surface fibres with it when removed from a soft paper. Papers vary, too, in the way they stand up to attempted alterations, and some of the hard-surfaced rag papers are surprisingly good in this respect; others are the reverse and with these any attempt to remove unwanted paint will ruin the surface. In most cases a bold, freshly painted error is preferable to a muddy, laboured correction and any attempt to remove paint from a pale passage such as a sky, is almost certain to be unsatisfactory. We have already noted that a bristle brush of the type used for oil painting is a useful tool for removing paint from a hard-surfaced paper, but care and patience must be exercised. Exact shapes can be removed with the help of masking tape: if, for instance, a triangle is cut in a length of tape which is then positioned and pressed down on the painting surface, a bristle brush will enable a white sail to appear against a darker sea. But work away from the tape,

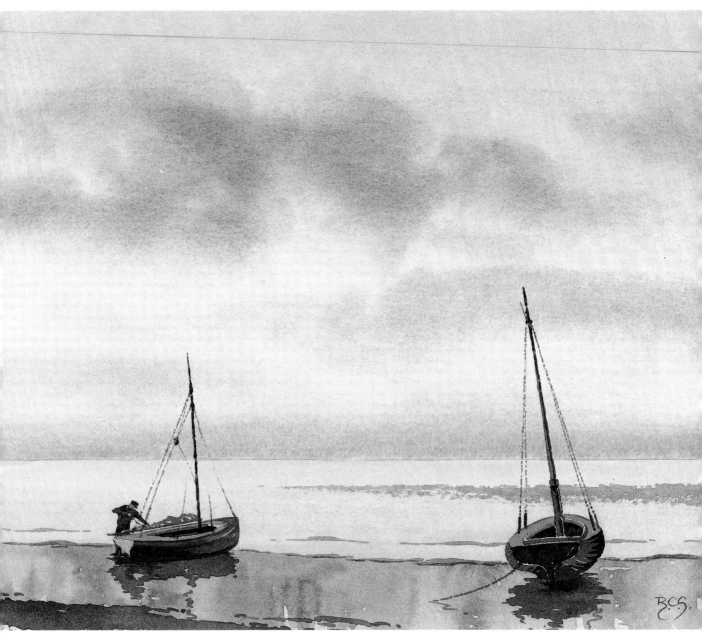

towards the centre of the triangle, or a ragged edge may result.

Constantly bear in mind that freshness and feeling are far more important than exactness and accuracy. Watercolour is at its best when it looks quick and spontaneous but this demands careful planning. Many painters fail because they experiment on their paper and consequently have to make many alterations and adjustments. If, instead, they thought their next step through, decided exactly what it entailed and then applied the required wash boldly, the result might not turn out precisely as planned, but it would be a vast improvement on a tired and overworked alternative.

Summer Evening, Norfolk (10¾in × 15in)
The sky was a pale variegated wash, Winsor blue and raw sienna at the top merging into raw sienna and a little light red above the horizon. While this was still wet, the soft-edged clouds were put in with a warm mixture of ultramarine and light red. The beached boats, the figure and the foreground sand were painted strongly to provide contrast with the pale sea and sky and emphasise their luminosity.

7

Demonstration

Plockton, Wester Ross (10¾in × 14¾in)
This group of white-washed buildings, on their little spit of land, stick out into a Scottish loch to provide a perfect natural composition. The light tone of the cottages made a crisp accent against the lowering, hump-backed hill beyond and the sunlit mountain towards the right contrasted pleasantly in tone and colour with its neighbours. The surface of the loch was ruffled by a gentle breeze so reflections were much reduced, particularly in the distance, where the two pale horizontal strips indicate the presence of stronger gusts of wind. The dark cliff on the right and the cloud shadows above help to balance the main weight of the composition, on the left.

Stage 1 It is often useful to make several quick sketches to find the best viewpoint. We will assume this is a full-size drawing of the most promising of the exploratory sketches. Until you are confident of your ability to capture a scene direct with the brush, a little careful drawing with a 2B pencil will ensure you get the composition you want. To aid reproduction, the pencil lines shown here are stronger than usual.

Study the sky – not for too long, or it will change – and decide how you will simplify it. Most cloudy skies are too complex for comfort and too many fiddly clouds would compete with the scene below instead of complementing it. Mix three full washes: the first of almost pure water with just a touch of raw sienna for the sunlit clouds, the second of ultramarine and light red for the cloud shadows and the third of pale ultramarine, with the merest suggestion of light red to dull it, for the misty sky beyond. Now establish the areas of sunlit cloud, bearing in mind that the light is coming from the left, and continue this almost colourless wash down to the water line, to avoid any unwanted hard edges. Then put in the cloud shadows letting them blend with the first wash and finally paint in the area of misty blue sky at top left, where a hard edge will provide some contrast.

Stage 2 Use varying tones of ultramarine and light red for the distant mountains and the shadowed areas of the nearer mountains and a pale mix of raw and burnt sienna for the distant sunlit mountainside. Drop in a little green here and there to vary the colours of the nearer slopes. Use a strong but fairly liquid wash for the hump-backed hill to ensure drying does not begin until you have finished painting around the rather complicated outlines of the buildings. If you have any doubts about your speed of working, you could use masking fluid for the chimneys and rooftops to enable you to apply the wash with greater speed. Make quite sure everything is dry before removing the masking fluid; even when the surrounding paper is dry, a tiny bead or two of wet paint sometimes remains on the impervious latex and if not spotted can cause trouble. Now begin to paint in the cottages in pale tones so that they will still register boldly against the dark hillside beyond.

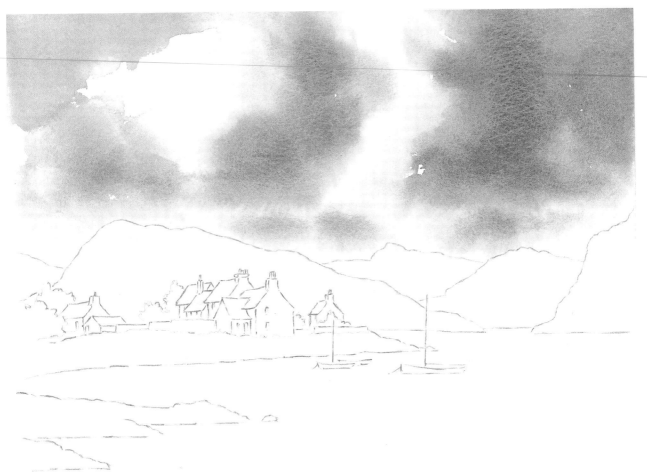

Stage 1 (above)

Stage 2 (below)

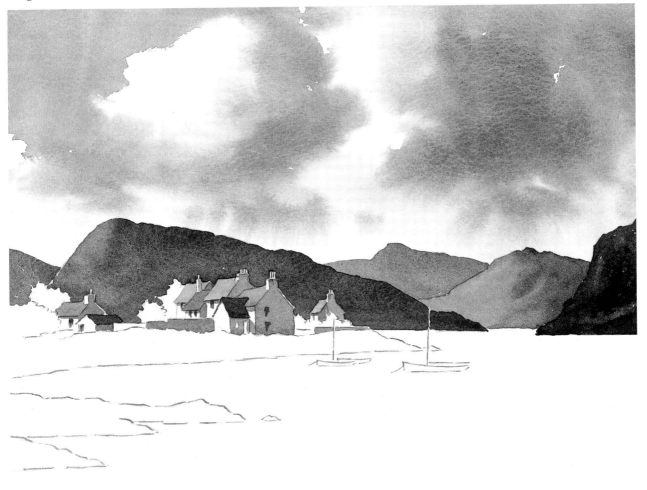

Stage 3 Continue painting in the cottages, paying careful attention to the shadows, using ultramarine and light red, with a touch of burnt sienna for the reflected light. Put in the trees and bushes with raw sienna and a little Winsor blue and add burnt sienna here and there for contrast and variety. Use a paler wash of the same green for the grassy area and when this is dry, add texture with a darker mix to indicate its rough surface.

Paint the water of the loch with a very pale wash of ultramarine and light red, using quick, horizontal strokes of a large brush and leaving two narrow bands of white paper to indicate the distant wind-ruffled areas. If you sweep your brush quickly over the paper, you will leave flecks of white paper which will suggest sunlight sparkling on the water. While this wash is still damp, add a few soft vertical reflections, using very pale versions of the colours above. It only remains to paint in the boats and foreground rocks in strong colours so that they stand out boldly against the pale water, and add their reflections.

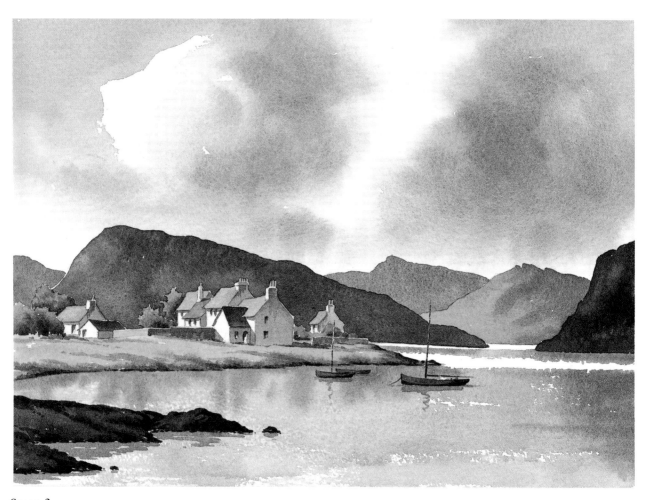

Stage 3

8
Light on the Landscape

The best-loved paintings are often those in which the artist has succeeded in capturing the effects of light, bringing life and a touch of magic to his work. The scenes which appeal to us most strongly as subjects are frequently those in which light plays an important or even dominant part. Light is the touchstone that gives a drab landscape radiance and a flat scene form and shape. It brings vibrancy to colour and, in reflected form, richness and depth to shadows. Turner was obsessed with light and spent his life trying to capture its elusive qualities in oil and watercolour. The French Impressionists rejected the drab palette of the artistic establishment and gloried in the prismatic colours of light to brilliant effect.

Artists cannot make their paintings emit light but, by knowledge and skill, they can create the illusion of radiance. How do they do it? The answer is by the clever use of tone and tonal contrast. If a light passage is surrounded by a much darker area, it will appear to shine by contrast. The watercolourist, by using clear, transparent washes, can let the paper shine through to create an impression of light. It is for this reason that students are always urged to make a thorough study of tone and to work out their tonal values with great care before committing brush to paper. Not only does tonal contrast help to suggest light; it also gives shape and form to the objects or scenes on which it falls.

Preliminary tonal studies are an excellent means of resolving, in advance, the problems of light and shade and, in addition, of assisting in the development of tonal judgment. In this context it is a good plan to ignore what you know of the local tone and colour of your subject and assess it objectively, which is not always as easy as it sounds. You may know the glazing bars of a window are white, but seen against a luminous sky they appear dark grey, and this is how they have to be painted. Students are sometimes advised to forget what their subject is, ignore what they already know about it and simply treat it as a mass of varying tones, shapes and colours. If they succeed, their work will be truer to life and may well be more effective and exciting.

Photographers, by controlling the amount of light that enters their cameras, can vary the tone of their subjects, to create mood and atmosphere. Artists can do much the same by raising or lowering the tone of their paintings, taking care that the relative tone values remain correct. Turner's watercolours of Venice are a case in point: by raising the tone of the scene before him, he created the illusion of light flooding the landscape. Lowering tone, to create a sombre mood, must be done with care, restraint and an understanding of the limitations of the watercolour medium. If used too strongly and heavily, it can easily appear dull and muddy and so lose its principal appeal.

One of the ways of focussing attention upon the centre of interest of a landscape is by bathing that part of it in light and by lowering the tone of less important areas. If the foreground were painted as though in deep shadow, the eye would quickly pass beyond it to the area of radiance. A brightly lit scene viewed through a shadowed doorway or window also commands immediate attention. These are both examples of playing lights against darks to good effect.

The sky is normally the lightest part of the landscape and here careful evaluation of tone is vital. If allowance is not made for the fading that occurs on drying, it could well finish up looking pallid, and if the rest of the painting is in tonal harmony, the end result will be weak and wishy-washy. If, at the other extreme, the deep tones of a stormy sky are overdone, there is insufficient in reserve for the still darker tones of the landscape below. So get all the practice and experience you can in assessing light values and judging tone, for competence will pay rich dividends in the future.

There are occasions when the sky is perceptibly deeper in tone than the landscape beneath, and this phenomenon can be used to powerful effect. A sombre sky can, by contrast, add brilliance to fresh snow and to shining water, while a sun-drenched landscape can create a dramatic counterchange against a stormy, grey sky. Such contrasts are a gift to the perceptive painter who will take full advantage of them.

Light can be used effectively in urban land-scapes. An industrial skyline against a warm band of light above the horizon, and city lights reflected in wet streets are just two possibilities that spring to mind. A keen eye and a lively imagination will discover many more.

Light is often at its most subtle and intriguing in misty conditions and here the watercolour medium can be both sensitive and expressive. Mist has the effect of softening outlines, greying colours and reducing tonal contrast. Wet-in-wet techniques can soften edges and suggest slight gradations of tone. It is a mistake to assume, uncritically, that mist is a uniform, pale grey – the enquiring eye will usually discover a range of soft, pearly colours as well.

Light has an immense influence on colour and without it colours cease to exist. The strength of the light and its temperature both modify the colours on which it falls. The Impressionists were preoccupied with glowing colour and often broke it down into its constituent parts, building up their sparkling effects with dabs of brilliant paint. In its purest form this technique was known as Pointillism and its most enthusiastic advocate was Seurat. As explained earlier in the book, colours

Evening, Fowey Estuary (10¾in × 15¾in)
Sunsets change with daunting rapidity and speed is essential if their fleeting effects are to be captured in paint. The feature of this particular sunset was the area of radiance just above the horizon from which the warm-coloured clouds seemed to radiate. This was put in first with pure water just tinged with raw sienna, and the clouds were added, wet in wet, with previously prepared washes of light red and ultramarine, and burnt sienna and ultramarine. From both these washes the warm colours separated a little on the wet surface, as intended, and more ultramarine was then added towards the edges of the paper. The sky washes were carried roughly two-thirds the way down the paper, leaving a hard but broken edge to represent the upper margin of the water. While the sky was still damp the distant landforms were put in with a wash of ultramarine and light red, plus, on the right, a little Payne's grey, to produce a soft-edged effect. Care was taken to ensure these washes were not too wet, for if they had been, unsightly run-backs, or flowering, would have occurred (see Chapter 6). The painting was then left to dry.

The water was put in next with two large brushes, one containing pale raw sienna, the other ultramarine and light red. Quick horizontal sweeps left broken lines of white paper to represent light sparkling on the surface. Once this was dry, the two cloud shadows were added with a slightly darker mix of the second wash.

Finally the boats and foreground were painted with strong mixtures of burnt sienna, light red and ultramarine. Notice how the nearer boats are placed against the light patch of sky and how their deep tones help to make it shine by contrast.

Even though the whole painting took less than half an hour, the light was fading fast and the painting was completed in semi-darkness.

Break in the Clouds, Wharfedale (8¾in × 13¼in)
A sudden burst of sunlight through a gap in heavy cloud cover can create a dramatic landscape subject. Here the middle distance is brilliantly lit while the far horizon and the foreground remain in deep shadow. The light also catches the walls and roofs of the farm buildings and these contrast strongly with the surrounding areas of shadow. The sky and the area of radiance were painted, wet in wet, with a wash of palest raw sienna and another of ultramarine and light red. Here again some colour separation has occurred, to give variety to the clouds. The distant mountains were a darker mix of the second wash and the foreground was painted strongly in various combinations of raw and burnt sienna and ultramarine.

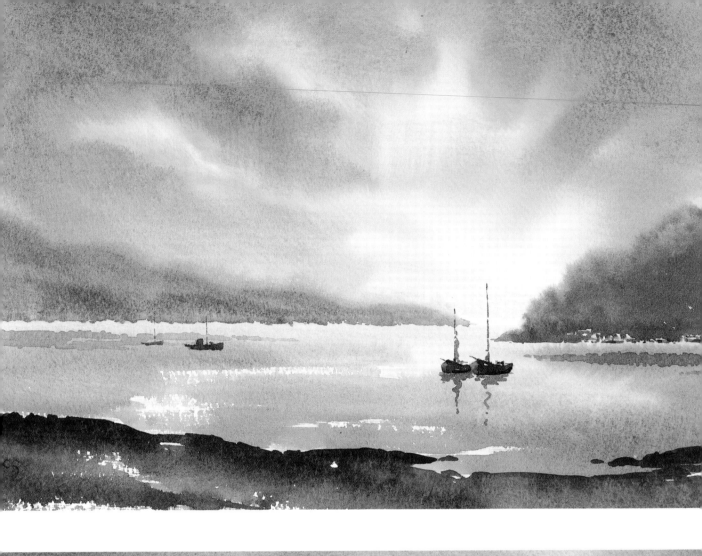

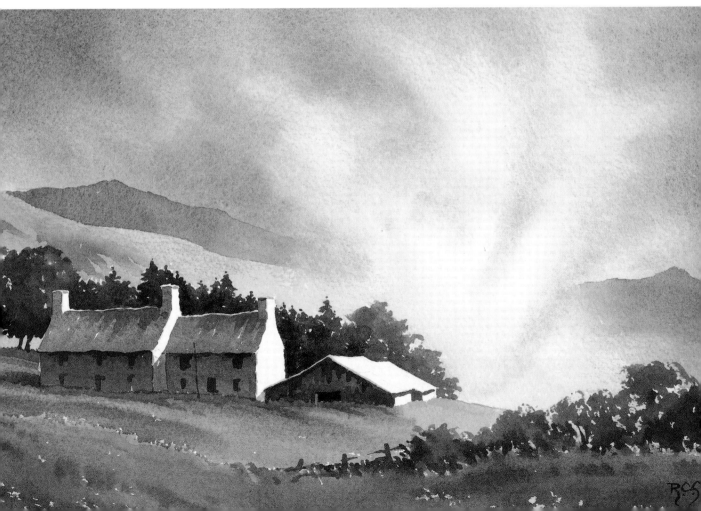

can be given added brilliance and impact by placing complementary colours against them.

Inexperienced painters frequently fail to study shadows in sufficient depth and are content to ascribe to them an all-over, flat grey. Just as the grey of the mist merits careful analysis, so the colours of shadows call for thorough investigation. Careful study will reveal all sorts of unsuspected colours and doing justice to them will bring shadows to vibrant life. This is particularly true when shadows are modified by reflected light, as, for example, when the shaded side of a street is warmed by light reflected from the sunlit buildings opposite. So ignore preconceived ideas and conventions, analyse tone and colour objectively and paint what you see with confidence and conviction. Light, in all its forms, is the key to it all.

(below)
The Weald of Kent from Chartwell
(9½in × 14½in)
Painting into the light can produce interesting effects. In this view over the clipped yew hedges of Chartwell, the back-lighting gives the trees haloes of radiance which contrast with the deeper tones of the shadowed foliage beyond. The effect of bright sunshine is suggested by the strong tonal contrast between the areas of light and shade, notably on the group of buildings which, incidentally, housed Sir Winston Churchill's studio.

First Snowfall (10in × 14⅝in)
On rare occasions the sky appears deeper in tone than the land below it but when snow has fallen this tonal inversion is the norm. The problem then is to emphasise the whiteness of the snow and this is done by painting the sky several tones darker. In this painting the snow is represented by the white of the paper except where a blue/grey has been used for the shadows. The lively, cloudy sky was painted in one go with a wash of ultramarine and light red and another of Payne's grey. Chips of white paper were allowed to remain to suggest highlights in the clouds and the use of both hard and soft edges gives interest and variety. The far hills were put in while the sky was still damp, and some controlled flowering suggests the ragged outline of distant coniferous woodland. The line of hedge was mainly dry-brush work and both the hedge and the man and his dog were painted in deep tones to provide contrast with the snow and make it shine.

Norfolk Creek (9¾in × 15⅛in)
Another simple painting, entirely concerned with light. Here the pale patch of sky and the light bands of water below are just the white of the paper and these contrast with the grey of the sky which is slightly warmed with light red just above the horizon. The darker, soft-edged clouds were dropped in while the first wash was still damp. The distant land forms of Gun Point and Scolt Head are grey silhouettes of ultramarine and light red. White paper also served for the sides and top edges of the two boats, to make a crisp note against the darker background.

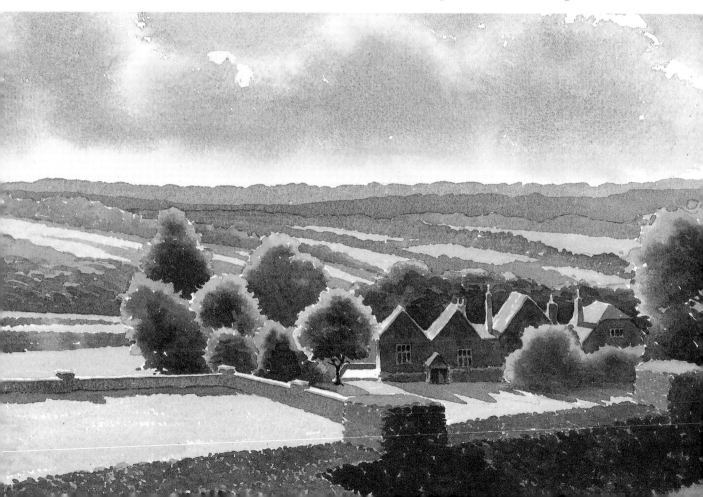

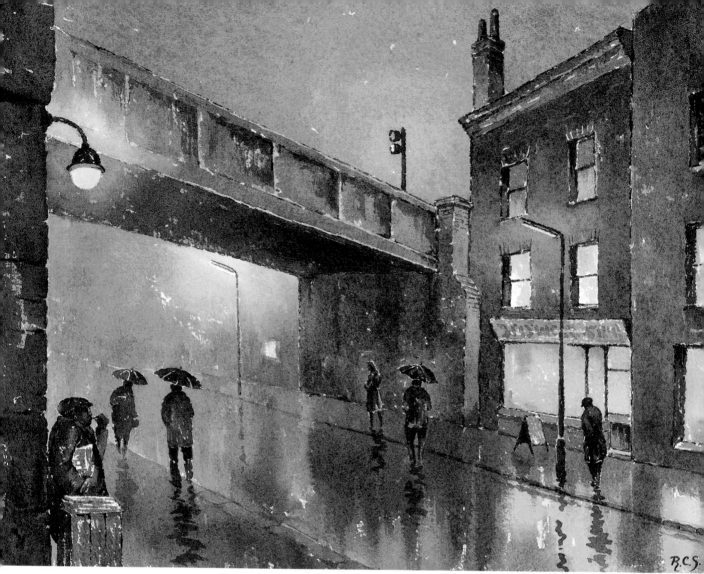

(above)
Railway Viaduct (10⅞in × 14¼in)
Street lights, lighted windows and their reflections in the wet street provide the only illumination in this painting of a foggy, drizzly urban scene. In the misty atmosphere the street lights produce a halo effect against the murky background. The dark figures stand out here and there against lighter areas. The only colours used were various combinations of raw and burnt sienna, light red and ultramarine and because of this the painting hangs together effectively. Despite the sombre mood there is plenty of tonal contrast.

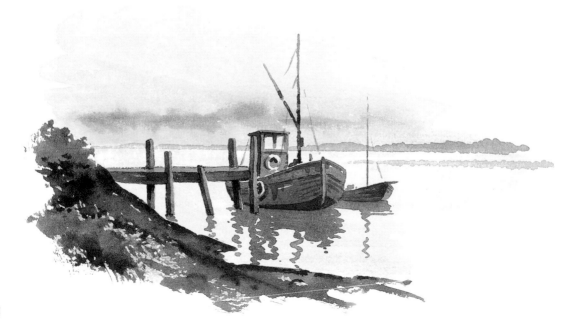

9
Reach for the Sky

Why is it that so many amateur painters fail to do full justice to their skies? Some seem to regard them as a necessary but troublesome background that has to be put in before they can get down to the more interesting bits of the landscape. Others stick to safe, graded washes because they have despaired of painting convincing-looking clouds. Even those who conscientiously try to get to grips with the problem often interpret too literally, put in far too much detail and in the process lose all life and freshness. Such failures are particularly unfortunate for the watercolourist because his medium, imaginatively used, is ideally suited to the painting of skies. Its clarity and freshness help to preserve essential luminosity and its speed of application makes it the ideal medium for capturing their fleeting changes of pattern and form.

In watercolour it is necessary to work fast and use plenty of water to achieve fresh and lively skies and this means that complex cloudscapes have to be much simplified. The meticulous portrayal of masses of tiny cloud shapes results in over-complication and a tired, over-worked

painting. It is far better to take your courage in both hands, employ a bold, watery technique and aim for strength and luminosity. A strong and dramatic sky can transform a painting and add enormously to its impact.

Skies are normally painted first for two main reasons. For one thing they are usually the lightest part of the scene and in watercolour it is best to paint from light to dark; for another, the sky exerts a vital influence over the rest of the landscape, and once it is established, the artist has a much better idea of how to treat the rest of the painting. A warm glow in the sky is reflected in the scene below and greatly increases the strength of the warm colours while an azure sky strengthens the blues of the shadows and of the far distance. This profound effect upon colour affects water even more strongly than land, as you would expect.

The placing of the horizon on the paper will depend to a large extent upon the nature of the sky. A strong, impressive sky merits plenty of space and this suggests a low horizon, perhaps

only a third or even a quarter of the way up the paper. If, on the other hand, the main interest is in the land, then a high horizon will be the answer and the sky will then play a secondary role. It is worth remembering that clouds and cloud shadows can be used to achieve tonal balance in a painting, a useful tip in a situation where most of the tonal weight occurs on one side of your chosen subject. Clouds are just as much a part of the composition as anything else and, if dominant, need careful positioning.

The most straightforward type of sky is the cloudless variety and this simply requires a variegated wash of the appropriate colours (the technique of the variegated wash is described in Chapter 6). Selecting the right colours is of the greatest importance and should be given careful thought. However brilliant the colour of the upper sky, an unmodified blue, straight from the tube, is likely to look too garish and ultramarine with a touch of light red is, for example, more pleasing in a watercolour painting than the pure

Cumulus.

Stratus.

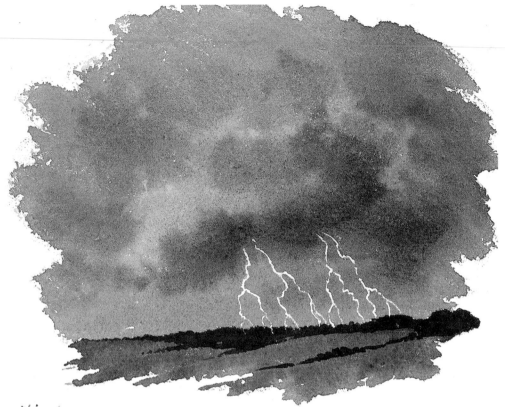

Nimbus

blue. The lower sky is seen through a much greater thickness of atmosphere and this has the effect of warming and softening its colour. Always remember to prepare washes strong enough to allow for the fading that inevitably accompanies drying.

You may wish to add a few clouds to your clear sky. If they are to be hard edged and darker than your variegated wash, you can safely wait until the paper is dry and simply paint them over that wash. If they are lighter in tone, you will have to paint your wash round them, blending the margins with clear water if you want them to appear soft edged. You can achieve the effect of darker, soft-edged clouds by dropping in greyish paint while the underlaying wash is still wet (the wet-in-wet technique) and here timing is all important. If the underwash is still too wet, the added paint will simply disperse into it, but if it has dried too much some hard edges and the unsightly effects caused by uneven drying will result.

There are four basic types of cloud and some knowledge and understanding of them is helpful to the painter:

Cumulus These are the full, rounded, billowing clouds with flat bases, the most paintable of them all.

Cirrus These are the high-level, fleecy-white clouds composed of frozen particles of moisture. Because of the strength of the wind at great altitudes they often seem to stream across the sky and in this form are known as mares' tails.

Stratus This is the term for the level cloud layers that may cover part of the sky or the whole of it.

Nimbus These are the ragged, shapeless storm clouds that usually presage bad weather. They are normally heavy and dark and can add drama to a painting.

Naturally, these classifications are not clear cut and there are often such combinations as cumulonimbus and cirro-stratus. There are occasions, too, when several of these cloud types are present at the same time. Another point to remember is that the laws of perspective apply just as firmly, if less precisely, in the sky as they do on the ground, particularly when the clouds in question are in fairly regular, serried ranks.

Once you have mentally simplified the cloud pattern before you, and reduced it to manageable terms, you have to decide upon the colours to be used, and prepare generous washes of each. Sunlit

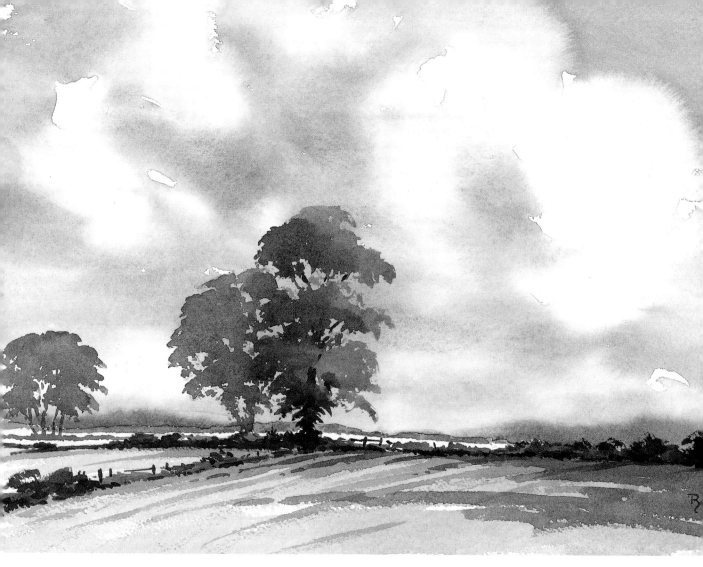

Autumn Fields (10½in × 14½in)

The clouds in this lively sky were a mixture of cumulus and nimbus and were painted at speed with a rich wash of ultramarine and light red and another of Payne's grey plus plenty of water. The billowing clouds at the top right were the result of flowering, as clear water was dropped on to the drying background wash.

The line of distant, blue-grey hills was painted while the sky wash was still damp, to achieve the desired soft-edged effect. The progressive greying of the trees conveys a feeling of recession. The broad treatment of the foreground fields does not attract undue attention as a more meticulous rendering would have done.

clouds may appear white, but there is usually a trace of warmth and the merest touch of raw sienna in the wash will produce this. Cloud shadows vary greatly in tone and colour. An excellent grey, with a hint of purple, may be made from ultramarine and light red, and this can be warmed or cooled by varying the proportions of these colours. Ultramarine and burnt sienna produce a cooler, softer grey. The same blue, slightly tamed by a touch of light red, is excellent for overhead skies, but has to be progressively softened and warmed as the horizon is approached. Once your washes are prepared, apply them boldly, using a separate large brush for each, allowing some blending to take place but preserving some hard edges to provide contrast. There are, of course, no hard-and-fast rules about this and some painters prefer the overall softness which results from wetting the paper first and allowing merging of washes to occur over the whole sky area. It is all a matter of personal taste. Some control of the washes will be necessary once they have been applied, to produce the effect you want, but the less manipulation and modification they receive, the fresher the final result will be.

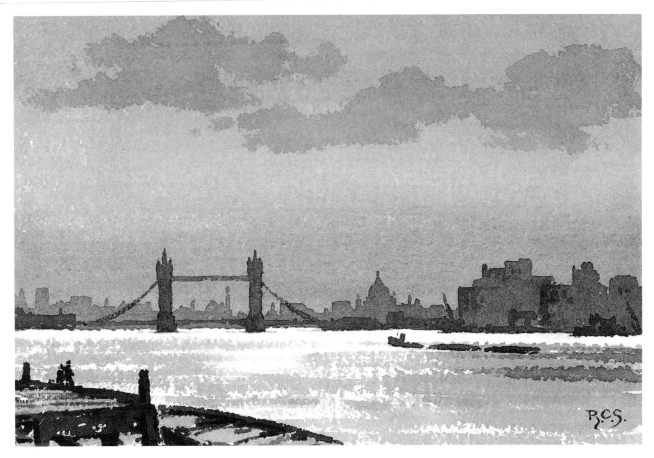

Sunsets have a powerful attraction for artists and, in fact, for all who have feeling for colour, but they are fraught with difficulty. However faithfully you try to match the colours you see before you, they have a way of looking gaudy on your watercolour paper. This is especially true of multicoloured sunsets with their brilliant pinks, purples, reds, greens, oranges and yellows. It is usually safer to confine yourself to those in which related colours predominate and avoid those which show all the colours of the rainbow. This does not mean you should play for safety in your painting of skies; on the contrary you should always be alert to such wonderful natural phenomena as areas of radiance and slanting shafts of sunlight seen against dark cloud formations, the dramatic contrast of sunlit landscapes against stormy skies and the magic of mist. All this, and much more, is there for you to capture, once you have acquired the skill to do it justice. A sketchbook kept handy for quick watercolour impressions of any skies that appeal to you will help you on your way.

The Pool of London (7¼in × 10¾in)
In this quick impression of the Thames, the sky was a full wash of ultramarine, light red and a little raw sienna, the proportion of blue being increased as the horizon was approached, to indicate the misty, smoky atmosphere. The cloud shapes were a darker version of the same wash and were added when the background wash was dry. A dragged-brush technique was used to give the impression of light shining on the water and this was helped by the rough textured surface of the paper. The successive lightening of the tones, from the foreground, via the middle distance, to the background suggests recession.

(overleaf)
Farm near Lechlade (10¾in × 14¾in)
A sunlit landscape against a dark and threatening sky can create a dramatic effect. Here the tonal contrasts have been deliberately exaggerated to heighten this effect. A painting of this type depends heavily upon tonal values and these should be worked out in advance with the aid of a preliminary sketch or tone study.

63

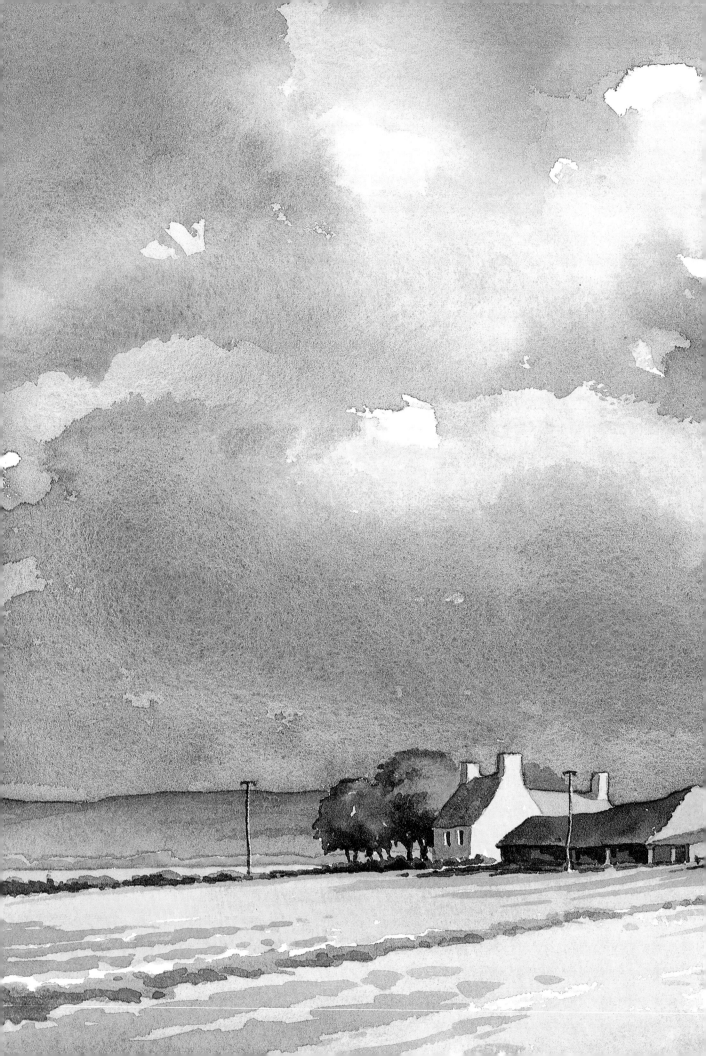

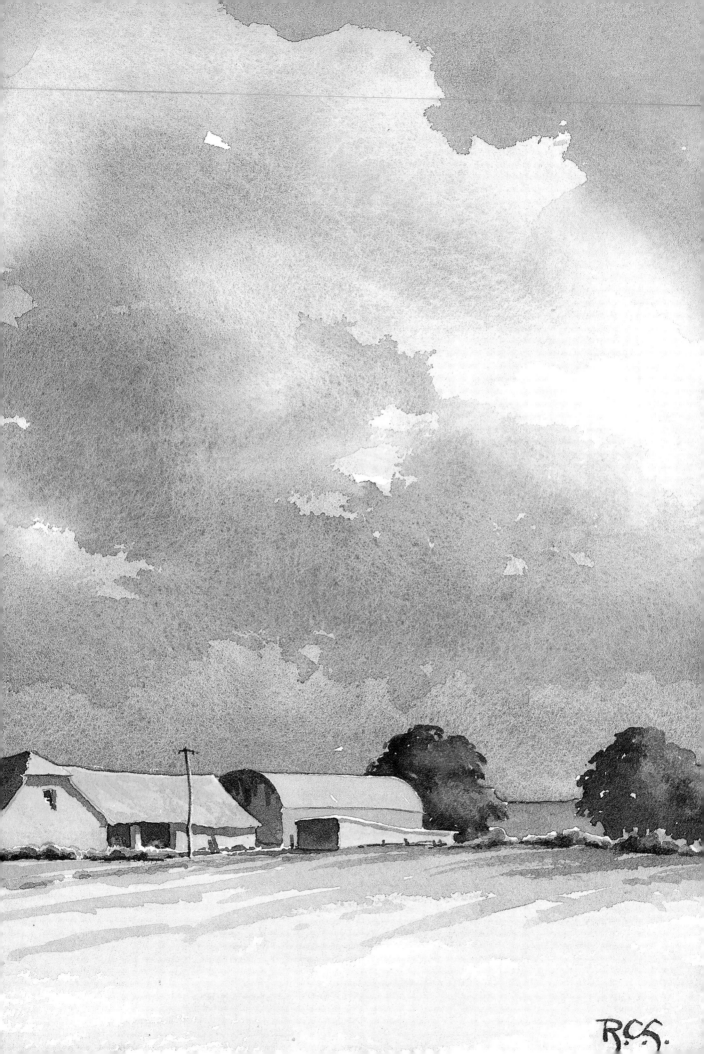

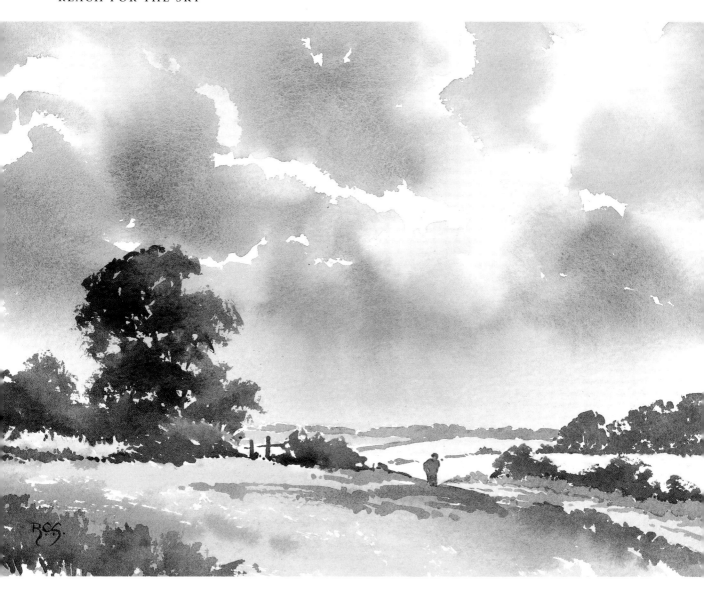

The Pilgrim's Way (10½in × 14½in)
*This ancient route to Canterbury winds its way across
the windswept downs beneath a lively sky. The loose
treatment of the clouds suggests their form and
movement while the combination of hard and soft
edges lends variety and interest to the sky. Burnt
sienna and light red, in varying proportions, were
mixed with ultramarine to produce the warm and
cool greys of the cloud shadows. The highlights were
simply the unpainted white of the paper.*

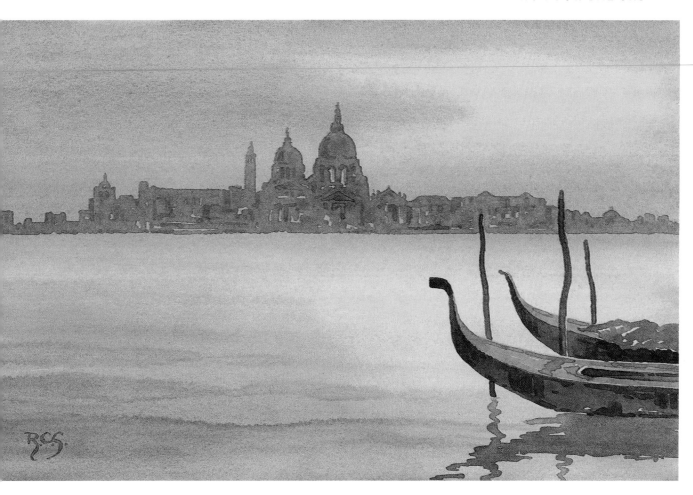

The Grand Canal (1) (8⅜in × 13in)
This simple rendering of a Venetian sunset illustrates two of the points made in the text. Firstly, the sky colours are closely related and, though strong, do not create the garish effect of a mass of disparate, competing colours. Secondly, there is an area of subdued radiance in both sky and water towards the right of the painting and this is accentuated by the dark tones of the distant buildings and the still darker tones of the foreground gondolas and mooring posts.

10
Of Trees and Foliage

There is no doubt about it, trees are the main stumbling block to good landscape painting. Aspiring artists who can produce splendid farm buildings and barns often fall down badly when tackling trees. This is particularly unfortunate for trees are a vital part of the rural scene.

Beginners frequently start by trying to paint every leaf and twig – a method that is almost bound to lead to tired, overworked paintings. Even when they have abandoned this approach, their results are often unconvincing and disappointing. In this chapter the principal problems will be tackled and practical solutions suggested.

When small children paint trees they often represent them as green spheres resting on brown cones and to them these Toytown images are recognisable and perfectly satisfactory conventions. It is when the painter begins to look more closely and searchingly that problems really start. Trees are extremely complex objects and their very complexity poses problems for the painter; and yet close observation must be the starting point.

Failure to paint convincing trees usually stems from a lack of understanding of their underlying structure. This can be overcome by going out into the countryside in winter and conscientiously sketching the bare branches and trunks of trees of all shapes and sizes. Observe how the branches are joined to the trunk and how they taper towards their ends. Notice, too, how some branches come towards you while others go away – they are not all laterals as often painted by the inexperienced! The basic knowledge of arboreal anatomy that you will acquire will help you enormously to paint trees in full leaf.

The next problem, which we have already touched on, is the amount of detail to include. This will vary, depending on how near or far the trees in question are to the painter. At one extreme, a bank of trees close to the horizon may well be put in with a single stroke of the brush for at that distance detail and tonal difference will be lost and only a flat shape in grey silhouette will emerge. Middle distance trees will reveal more of their individual shapes, and differences in tone between sunlit and shaded areas will become more apparent. Foreground trees will, of course, show the most detail and the greatest difference between lights and darks. In varying the amount of detail and tone in this way you will also achieve a feeling of recession and this must be reinforced by increasing the soft grey-blue colour content of the trees as they recede into the distance.

In this discussion of the amount of detail required, no mention has been made of how it may best be suggested in watercolour. The answer is to school yourself to see trees as masses of tone and colour. If you screw up your eyes, detail is lost and foliage resolves itself into adjacent areas of light and shade. It is these areas that should be analysed for tone and colour and painted quickly and boldly with pre-mixed washes. They will not be clear cut, probably merging at their margins, and this effect may be obtained by allowing the adjacent washes to blend. In most trees there are 'sky holes', or gaps in the foliage through which the sky can be glimpsed, and these should be indicated, in simplified form, in your painting. It is through these gaps that trunks and branches are often seen. At all costs avoid superimposing a complete system of trunk and branches on top of the green of the foliage!

The outline of the typical tree, made up of thousands of twigs and leaf clusters, is a very broken and ragged affair and the problem is to achieve this effect without resorting to numerous little dabs of paint, which always look repetitious and laboured. One way is to hold the brush containing the green wash almost parallel to the paper, so that its side makes contact with the little hills in the paper's surface but misses the little hollows. The use of a rough-surfaced paper obviously assists this technique. The resulting rough outline has an unlaboured and unforced look about it and in watercolour the more spontaneous the effect the better. If all the foliage is painted in this way, with one wash, the outline may be perfectly satisfactory, but the tree will look somewhat flat, almost like a cut-out. To

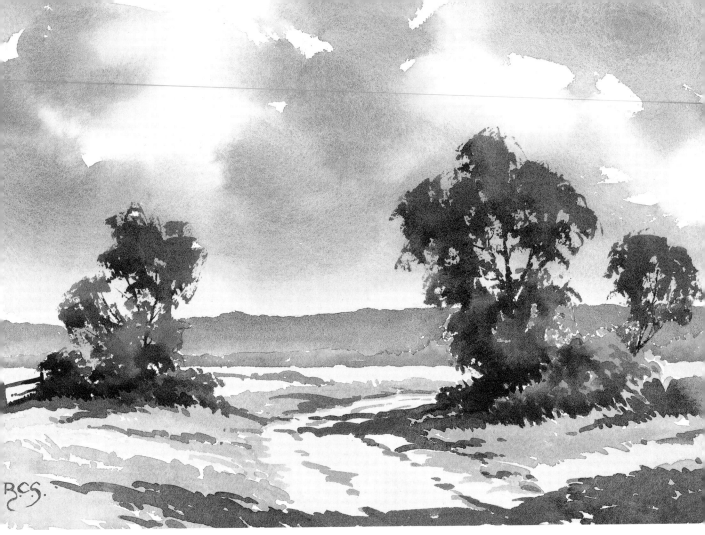

achieve a three-dimensional effect, the shadowed side of the tree and the undersides of the main branches should be painted in a deeper-toned wash, and the two washes allowed to merge. As you become more proficient, you may well employ more washes in this manner to deal with further colour variations that you have identified.

There are far more colours in foliage than beginners generally realise. Too often they content themselves with an overall green wash and their shadowed areas are just a deeper tone of the same green. In high summer, it is true, green is a very persistent colour in the rural landscape, but there *are* other colours and it is vitally important to search for them and perhaps even exaggerate them, to give life and interest to your painting. Look for those touches of yellow, orange and brown that give variety to foliage and observe the variations of green between trees of different species. Shadowed foliage, too, has variations in colour and is not just unrelieved dark green, so look for the purples, the browns and the greys that will give life and vibrancy to your shadows.

The colours of the trunks and branches of trees also need careful scrutiny for they are rarely the conventional brown they are often painted. Silver greys and grey-greens abound while the lower

The Road to the Downs (10½in × 14¾in)

The foreground trees were painted using the side of the brush to achieve a broken outline and a deeper wash was then dropped in to indicate the shadowed areas. Sections of trunks and branches were established in the 'sky holes' while the foliage was still wet. The distant wooded hills were a single wash of ultramarine and light red. Notice how the tree shadows reflect the unevenness of the ground.

trunks are frequently moss green. Pay particular attention to the way shadow falls on branch and trunk for this can help to describe their cylindrical form. Notice, too, how tree shadows are affected by the unevenness of the ground over which they fall, and avoid the mistake of painting them as though they are lying across a billiard table surface!

The intelligent use of shadows can add greatly to the impact of your work and help to solve a number of problems. An over-prominent road or track can be conveniently broken up by tree shadows falling across it. Always remember to make these shadows follow the contours of the ground, down the roadside bank, up over the camber of the road, with little indentations as they pass over ruts and wheel tracks, and then up over the other bank. All this will help to describe

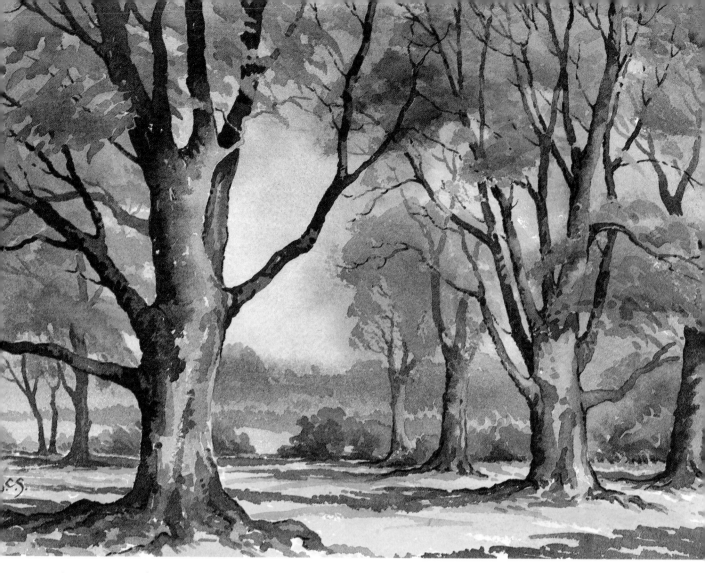

Autumn Woods (10¾in × 14¾in)
The colour green has been played down in this impression of beech woods in autumn and seasonal russets and browns have been emphasised. A soft purplish-grey for the distant trees and hills indicates recession. The beech trunks are a pale grey-green in the sunlight, but the shadowed branches are much deeper in tone, particularly when viewed against the sky. Once again the tree shadows suggest the unevenness of the ground.

the surface of the ground. Interest can sometimes be lent to an empty foreground by letting the shadows of trees outside the composition fall across it, again taking care to ensure they reflect the roughness of the ground.

The mass of twigs on bare winter trees needs just as much simplifying as summer foliage to render it amenable to broad watercolour techniques. Here the ends of the branches can be carried up into dry-brush work or into a pale wash of the appropriate colour. This wash must,

of course, be lighter in tone than the twigs themselves for it represents not only the twigs but the sky between them.

There are various ways in which the height of forest giants may be emphasised. They may, for example, be allowed to pass out of the top of the painting, or tiny figures may be placed alongside to provide scale. Variety may be introduced into the treatment of groups of trees by painting the trunks in contrasting tones: some may be light against a dark background, others may be dark against a patch of light foliage. Sometimes a sunlit scene may be accented by putting in a frame of foreground leaves in shadow. These are just a few examples of how emphasis, contrast and variety may be introduced into your painting: keen observation and your own imagination will suggest many more.

Make a habit of sketching trees or groups of trees whenever you see an interesting arrangement. This will not only improve your technique but will provide you with material for future use.

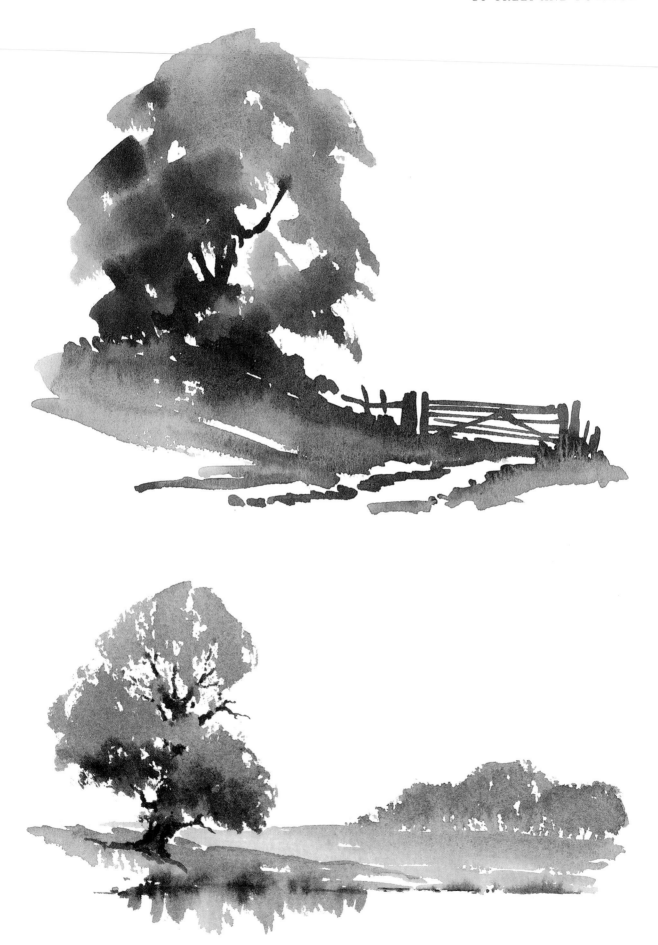

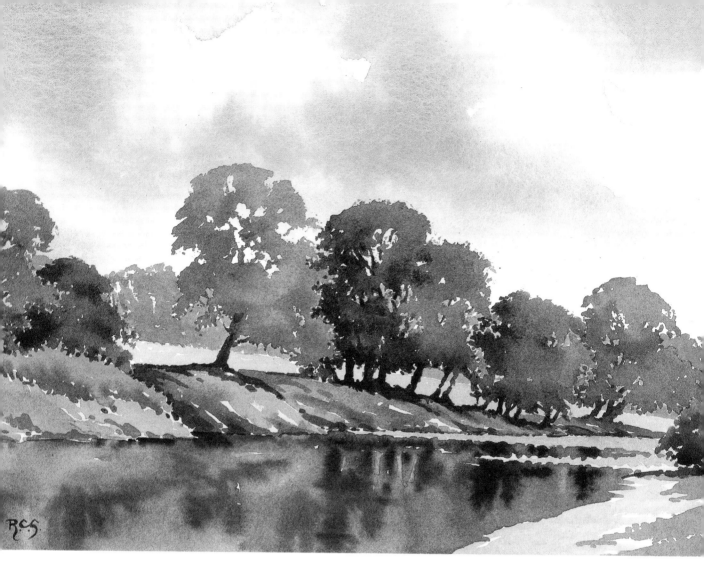

The River Medway (10¼in × 14in)
Here the breeze has ruffled the surface by the bend in the river to produce pale stretches of water which conveniently separate the mass of foliage from its reflection below. The wide variation in the colour and tone of the trees has been emphasised while the use of blue-grey for the distant hillside suggests recession.

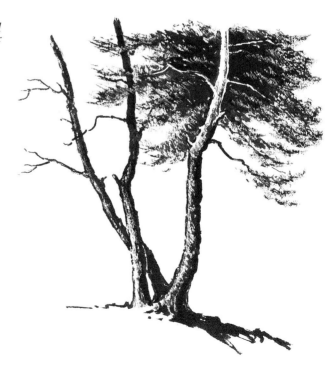

Brush and Indian ink sketches of tree groups.

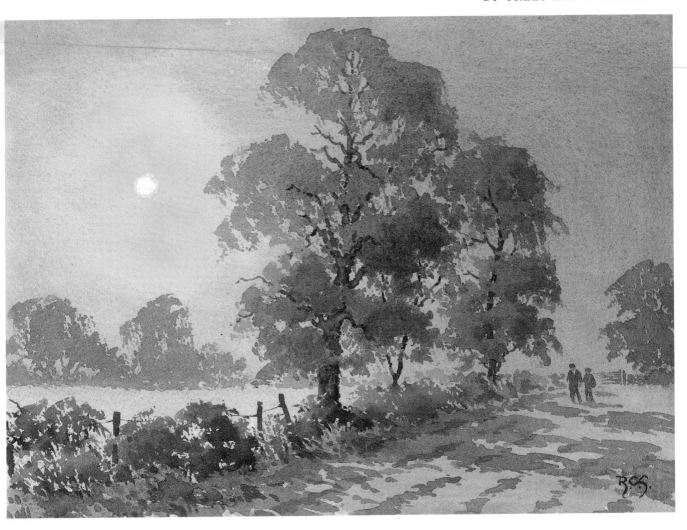

Autumn Mists (10¾in × 14⅜in)
The glow from this misty evening sky influenced every part of the scene so the trees, hedges and fields were painted in suitably warm colours : various combinations of raw sienna, ultramarine and light red.

The broken outlines of the trees and hedges were effected by using the side of a no 10 brush on rough rag paper. The line of distant trees is about one-third the way up the paper and the group of foreground trees is placed to the right of centre. Notice how the line of hedge carries the eye to the two small figures which provide scale.

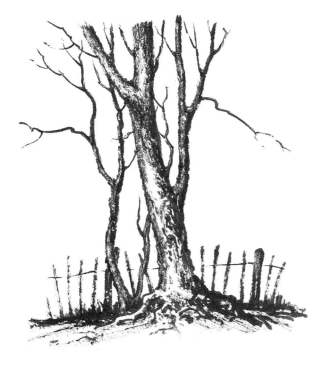

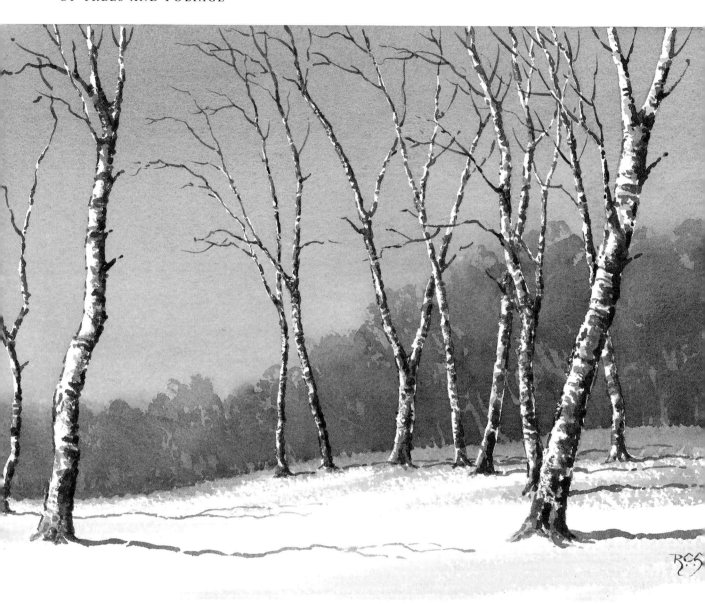

Birches in the Snow (10¾in × 14½in)
*Masking fluid was used to preserve the whiteness of
the birch trunks and main branches while a graded
wash was applied for the sky (ultramarine touched
with light red shading into ultramarine and raw
sienna). While the paper was still damp a mixture of
light red and a little ultramarine was painted wet in
wet, for the bank of trees. Once drying was complete,
the same mixture, plus a little more ultramarine was
applied to provide form and texture for the distant
trees. A very pale wash of ultramarine slightly
warmed with light red was applied to the snow
beneath these trees and a darker version of the same
mixture provided the shadows of the foreground
birches.*

*When the paper was again completely dry, the
masking fluid was removed and texturing applied to
the white trunks and branches. Quick, tapering
strokes of the rigger dealt with the smaller branches
and twigs which appeared dark against the sky.*

11
The Trouble with Foregrounds

The last part of the painting to be completed is usually the foreground. If everything has gone well up to that point, you will be understandably anxious not to spoil what you have already achieved. But beware! Your anxiety may easily lead to overworking and over-elaboration which will spoil your work in several different ways.

If your foreground consists, for example, of grass or foliage of some kind, excessive care may result in your attempting to paint every leaf and every blade of grass. This labouring after detail may easily produce a tired, over-meticulous painting from which the main attractions of watercolour – its freshness and clarity – will have departed for good. Excessive preoccupation with the foreground has another serious disadvantage, for it draws the attention away from the important part of the painting. Instead of supporting and complementing the centre of interest, the foreground then competes with it and the whole balance of the painting is upset. And if there is too much detail in just one area, the painting will no longer 'hang together'.

It is, therefore, good sense to make a determined effort to avoid fussy foregrounds and to simplify whenever you can. This broad treatment is in line with what you see, for if your eyes are focussing on your centre of interest – perhaps an attractive group of buildings in the middle distance – the foreground will be on the periphery of your field of vision and will not be seen sharply or in detail.

The overworking of foregrounds is often due to the painter's compulsion to paint exactly and literally what he sees, and to his inability to simplify. His treatment of distant foliage may be perfectly satisfactory because he is too far away to see small details and is forced to paint broadly. It is when he *can* see every leaf and twig that his troubles start. The solution is to throw the subject matter out of focus by viewing it through half-closed eyes, a ploy suggested in an earlier chapter. In this way detail is lost and only broad areas of tone and colour remain.

Large brushes will help you to achieve bold effects and will make it difficult to include fiddly details. Bold strokes of the brush may leave clusters of white specks in their wake and these can suggest texture of some kind. In watercolour, quick, almost accidental effects are far more telling than careful, meticulous ones and nowhere is this more true than with foregrounds. There are, of course, occasions when the foreground is the centre of interest and the background plays a secondary role. Foreground features will then be painted more strongly while the distance and middle distance are played down and softened.

Texturing techniques are useful for describing the appearance of such materials as old wood, masonry, rock, rough grass, scrub and so on. These are worth practising to enable you to obtain the desired effects boldly and without labouring after detail. Conventional brushwork can do all that is necessary though there are a number of tricks which can produce specialised effects. There is no harm in experimenting but remember that too many tricks can impart a gimmicky appearance to your work.

Practise broken washes, to suggest light sparkling on water, light catching seed-heads in a meadow and many other effects.

Light sparkling on water

Meadow – broken wash

Use the side of the brush and the roughness of the paper to paint foreground scrub or a line of hedge.

Foreground scrub

Line of hedge

Dry-brush work can be used to capture the rough textures of old wood or rock.

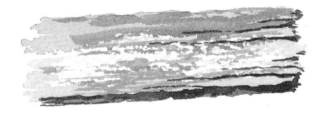

Old Wood

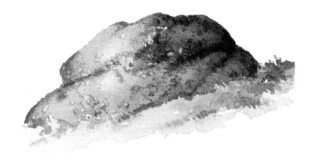

Rock

Now for a couple of tricks! Salt sprinkled on a wet wash can produce a speckled or mottled effect. Sand and various other materials can be used in much the same way. Crumpled paper pressed onto a drying wash can suggest rock and other rough surfaces.

Sprinkled salt

Crumpled paper

There are many more tricks, and indeed books have been written on the subject, but you will do better to rely on your brushwork. As with so much in painting, it is all a matter of practice, but gaining dexterity and skill with the brush is well worth the effort.

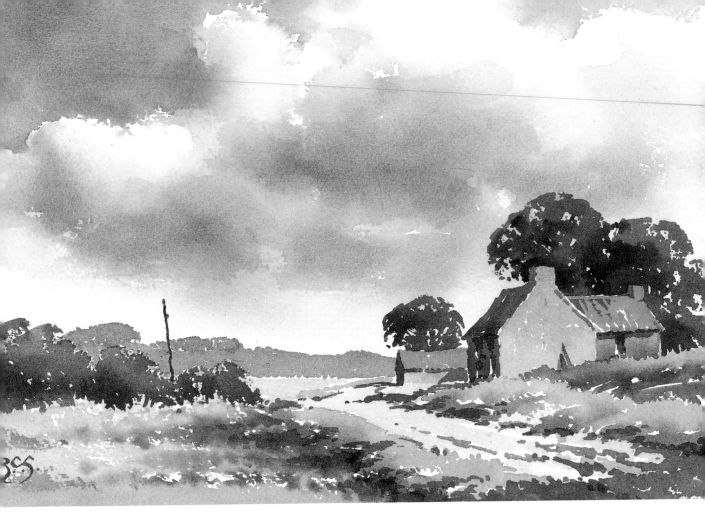

Farm Lane (10½in × 14⅝in)

A simple subject, simply treated. The farm buildings and trees on the right are balanced by the bushes and the heavy clouds on the left, while the low horizon enables justice to be done to the lively sky. Notice how the farm track leads the eye into the heart of the painting.

The blue-grey of the distant wooded hill contrasts with the warmer colours of the foreground and strongly suggests recession. The dark trees throw the lighter tones of the farm buildings into relief and the dark line of hedge on the left contrasts with the pale colours of the adjacent fields.

The general treatment is free and direct and if there had been any over-elaboration of the foreground, the balance of the painting would have been destroyed. As it is, the foreground has been tackled even more boldly and loosely and so does not attract undue attention at the expense of the rest of the painting.

A rough rag paper was used and its textured surface made its contribution to the broken outlines of fields and trees. The rapid technique left many specks of white paper, but these impart life and sparkle to the painting.

The sky and the distant wooded hill were various mixtures of ultramarine and light red. The fields were mainly raw sienna, with darker accents of light red and ultramarine; the grass on either side of the track was raw sienna plus a little Winsor blue and the trees and bushes were various combinations of raw sienna, burnt sienna and Payne's grey.

(overleaf)
White House Farm (10½in × 15in)

In this painting the strong verticals of the conical oasthouses contrast with the mainly horizontal forms of the fields and the receding banks of trees. The time is autumn, the hops have long since been dried in the oast kilns and the rich scent that pervades the late September air has also gone. The light is coming from the left as the shadows falling across brickwork and whitewash indicate.

The foreground was rather overgrown and the long tangled grasses and weeds have been suggested very loosely, advantage again being taken of the roughness of the paper's surface to obtain a broken effect. The dog daisies on the right have been given a little more detail, but not enough to enable them to compete with the centre of interest, in this case the old white farmhouse. The colours used in this painting were raw sienna, burnt sienna, light red, ultramarine and Winsor blue.

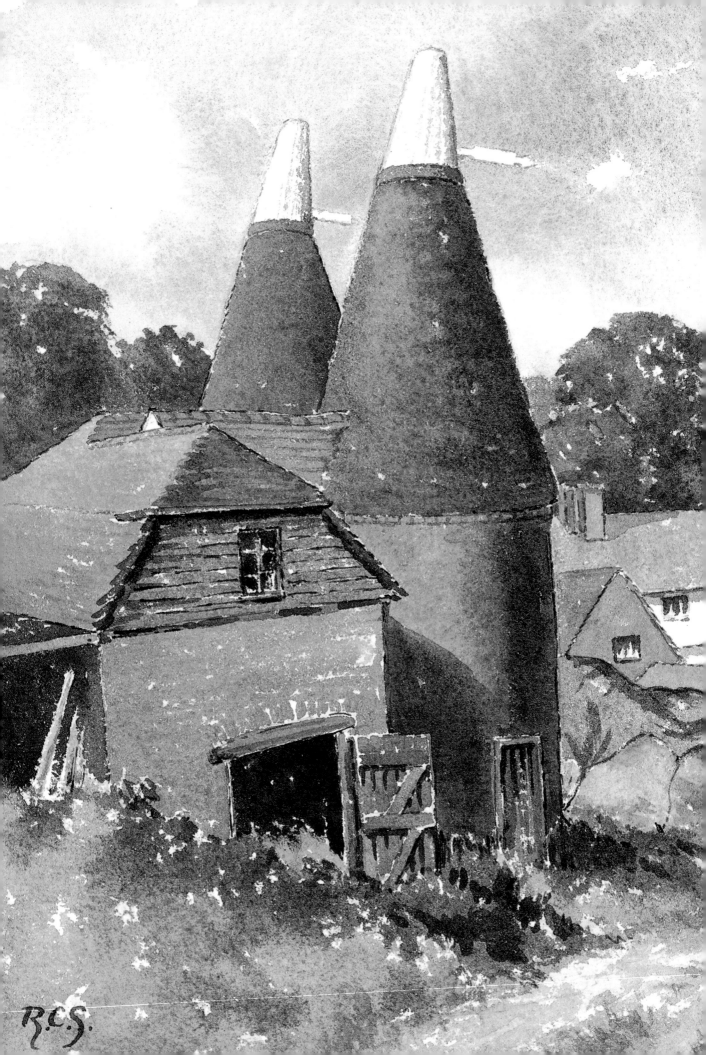

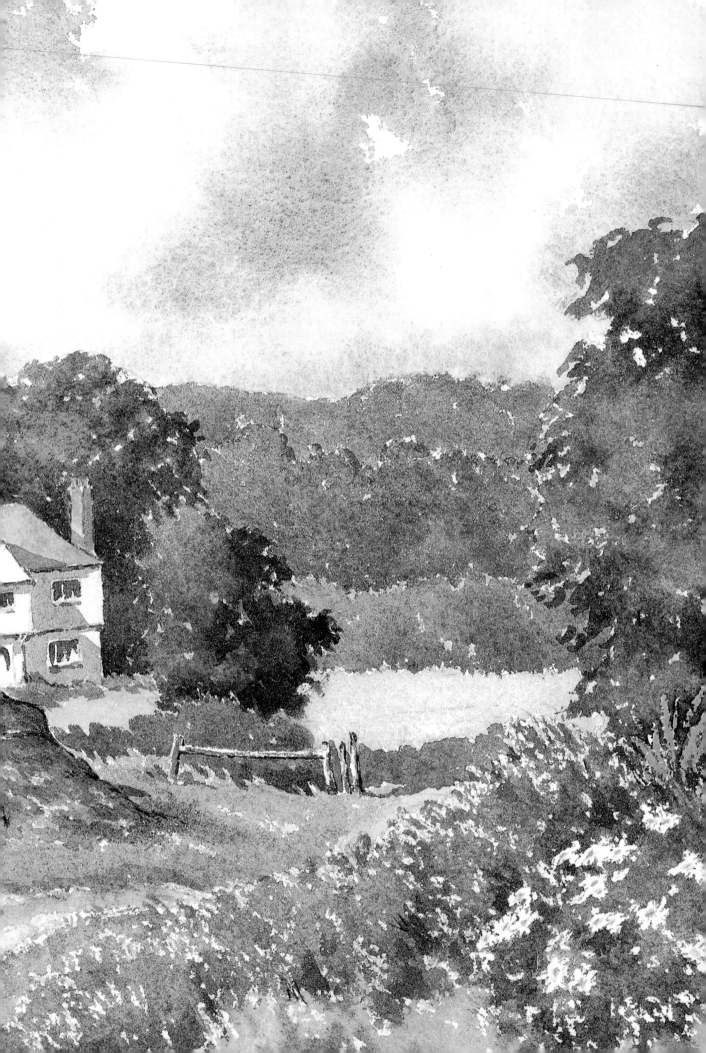

12
Demonstration

Sailing Barge at Anchor (9¾in × 13¾in)
The old wooden sailing barge, anchored in a sheltered estuary, is surrounded by several smaller craft and their reflections make an interesting pattern in the calm water. It is a fine evening in late summer, with not a cloud to be seen and were it not for the distant stretch of land, sky and water would be indistinguishable at the horizon. The dark foreground of mud and shingle makes a strong contrast with the expanse of shining water.

Stage 1 Make several quick sketches from different viewpoints and let the most promising of these be the basis of your composition. Boats are tricky subjects and require careful drawing. The lines of this sketch are, once again, stronger than they would normally be, to aid reproduction.

The sky is a soft blue, shading into a pale warm yellow above the horizon and these colours are reflected in the water. A variegated wash over the whole paper is the best answer here. Prepare two generous washes, the first of ultramarine and Payne's grey, the second of raw sienna with a little light red. With a 1in brush start painting horizontal bands of blue, starting at the top of the paper and working your way down. After several sweeps, start dipping the brush into the second wash, so that a gradual change to the soft yellow

occurs. Right at the bottom of the paper reverse the process, and again dip your brush into the blue wash. If you have been successful, there will be an even transition from cool to warm colour and, at the bottom of the paper, a hint of a return to the cool. If this technique causes you difficulty, you may find it helps to dampen the paper evenly all over before starting to apply the bands of colour.

Allow the paper to dry and apply a wash of ultramarine and light red to the strip of land beyond the water. This should be stronger on the right, with a hint of green, and weaker on the left, where the land recedes.

Stage 2 Now paint the furled, russet sails of the barge with light red and burnt sienna tinged with ultramarine. They should stand out boldly against the light sky, so use a strong wash. While this wash is still damp put in the shadows and the folds with a stronger version of the same wash, plus a little more ultramarine. Use various combinations of burnt sienna, light red and ultramarine for the old wooden hull and the smaller craft, again using fairly strong washes so that these shapes will register decisively against the shining water. Take particular care to preserve the top edges of the boats where these catch the light.

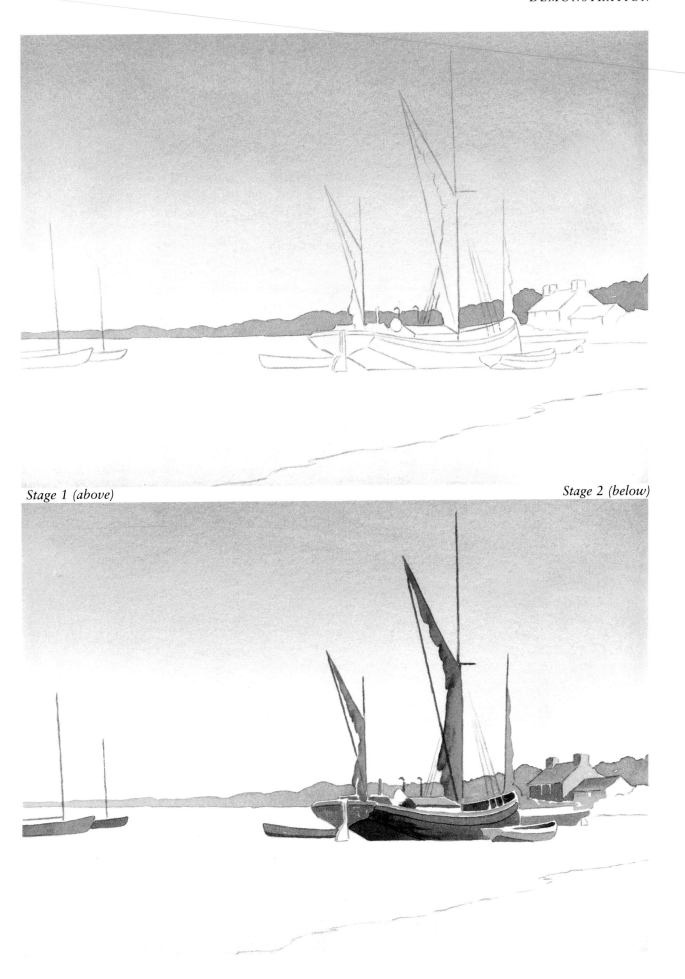

Stage 1 (above)

Stage 2 (below)

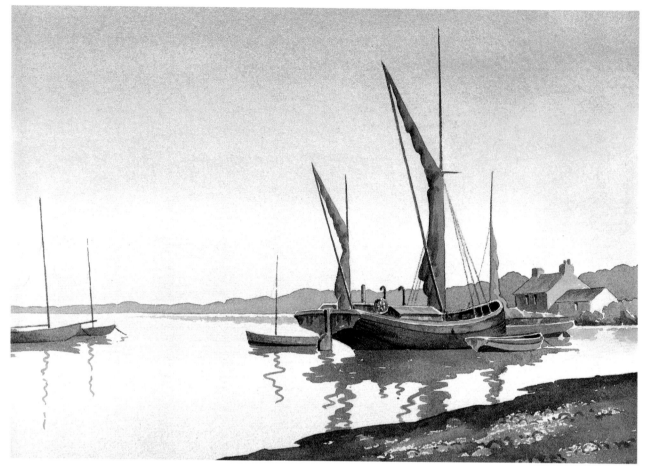

Stage 3 Complete the painting of the boats, add a little texturing to the weathered hull and put in a suggestion of rigging. Do not try to include every rope or the painting will end up looking like a cat's cradle.

Now for the important part – the reflections in the smooth water. These are best put in quickly, in one operation, so prepare several liquid washes, of brown, blue and grey, to correspond roughly to the colours above. Remember the adage: light objects are reflected darker, dark objects are reflected lighter, so ensure that these reflections are lighter in tone than the boats above them. Use bold, rapid brushwork so that the blended washes remain clear and fresh.

It now only remains to paint in the dark foreground. Quick strokes of a 1in brush loaded with a strong mixture of burnt sienna and ultramarine will produce a broken wash which will suggest shingle. With a stronger mix of the same colours accent the margin with the water to provide contrast and, with a small brush, outline roughly a few foreground stones and pebbles.

(opposite)
The Packhorse Bridge (9⅛in × 13¼in)
This wild and empty scene needed a focal point in the foreground and the old stone bridge provided just what was required. It stands out boldly against the deeper tones of the middle distance stretch of moorland and its reflection adds interest to the shallow river. The stormy sky is strongly painted and the crest of the main peak, placed just left of centre, gains impact from being in deep cloud shadow, contrasting as it does with the lighter patches of sky and the gleams of sunlight on the lower slopes.

The light areas of cloud were put in first with a wash of palest raw sienna and the grey cloud shadows added with a mixture of ultramarine and light red. When this was dry, the same grey wash was used to *strengthen the cloud shadows above the peak, and here some hard edges were left while others were softened with clear water. The same grey was used for the distant mountains and while this was still wet a little liquid raw sienna was dropped in to suggest the misty areas of sunlight. Still darker accents were added, wet in wet, to the peaks to increase their dramatic impact.*

For the stretch of middle distance moorland the light red content of the same wash was increased to indicate dark patches of heather and here, too, raw sienna was used to suggest sunlight. The foreground rocks and grass and the river itself were put in quickly and boldly with various combinations of the same three colours.

13
The Magic of Mountains

I can still recall the feeling of wonder I experienced on seeing my first mountains. They were in the Lake District and although by international standards they were pretty modest affairs, to a small boy who had seen nothing higher than the North Downs they represented excitement and adventure. I lost no time in climbing them and painting them. My paintings, I remember, grossly exaggerated both their altitude and their steepness and were no doubt intended to impress my peers with my prowess in conquering them. This love of mountains has never faded and is shared, I believe, by most painters. They make magnificent subjects for the watercolourist with their subtle tones and colours and their interrelation with mist and cloud.

One of the problems of painting mountains is their inaccessibility, particularly for those who no longer possess the vigour of youth. True, there are many wonderful compositions beyond the reach of all but the strongest and fittest but there are many more visible from points in the valley which anyone can reach. Of all natural subjects, mountains repay most generously the effort of painting them in situ, and rough impressions done on the spot nearly always have more punch and appeal than more finished paintings made in the comfort of the studio. The fleeting changes of light, the cloud shadows moving over the fells and the effects of mist and low cloud have to be seen at first hand and nothing else can provide the same inspiration.

It makes good sense to limit the amount of equipment you take with you on painting expeditions to high places. The watercolourist is fortunate here for apart from his drawing board he can carry all he needs in a small haversack and still have room for his picnic lunch. If you paint

In the Alps (10½in × 14in)

In this quick impression of an Alpine scene, the tones are reversed and the sunlit, snow-covered peak is a brilliant white against the dark grey sky. The snow is untouched white paper, but the deep tones of the cloudy sky make it shine as do the dark patches of rock which are exposed near the summit. The snow shadows are pale ultramarine with just a touch of light red.

The foreground is treated boldly and freely and the figures of the two climbers, painted in silhouette against a patch of white snow, add scale and interest to the scene.

with the drawing board on your knee, you can dispense with an easel which in any case is vulnerable in the strong winds often experienced at high altitudes. With plenty of rocks about, even a folding stool is an unnecessary luxury. A piece of plastic sheeting can protect your work in the event of a sudden shower and can double up as a small groundsheet if the ground is wet.

Maps are indispensable for trips into the mountains and if you read them carefully they will show you where there are extensive views and where to find rivers, streams, rocky outcrops, isolated buildings and so on. Sometimes you will wish to emphasise the loneliness and emptiness of the mountain scene; at other times the inclusion of a lonely farmhouse will provide a focal point and suggest scale. The human figure can perform much the same function. It all depends upon the composition of the scene before you and upon the mood you wish to create.

Foregrounds have a vital part to play in planning your composition. Strongly painted rocky foregrounds not only set the scene but, by tonal contrast, can emphasise the feeling of aerial space and the mystery of the distant vista beyond.

Just as groups of trees from the sketchbook can be used to fill empty spaces in the landscape, so studies of rocks can be pressed into service to provide foreground interest where none exists. So here, too, a well-stocked sketchbook is of real value.

The very extent of the mountain panorama makes it imperative for you to simplify and concentrate upon the main features of the scene. A dominant mountain peak will have far more dramatic impact if painted boldly and in broad outline than if every rock and indentation were painstakingly recorded. So aim for atmosphere and omit insignificant detail.

Mountain scenery is often at its most dramatic when the weather is at its worst and it is sometimes necessary to brave low cloud, mist, rain squalls and even snow to capture the effects you want. So be prepared for the worst that nature can throw at you and remember it is nearly always colder at high altitudes than you expect.

In Upper Wharfedale (10¾in × 14½in)

The subject of this painting is a very different type of mountain scene, with a strong domestic flavour. Here the accent is on the jumble of cottages rather than the hilly background. Indeed, the stark outline of the ridge is little more than a flat wash of grey and even the nearer shoulder of hill has only a broken, secondary wash added to suggest woodland and scrub. They do, however, form an effective background and provide an authentic setting.

The geometric shapes of the cottages, with their solid stone walls and their rough stone slates, form an interesting pattern. This is emphasised by the strong interplay of light and shade which helps to give the scene a three-dimensional appearance. No attempt has been made to paint every stone in the cottage walls, but the inclusion of a few random blocks suggests their construction and leaves something to the imagination.

Notice the reflected light in the shadowed elevation of the centre cottage and the hint of green algae in the lower courses of the stone slates – little touches such as these can breathe life into a painting.

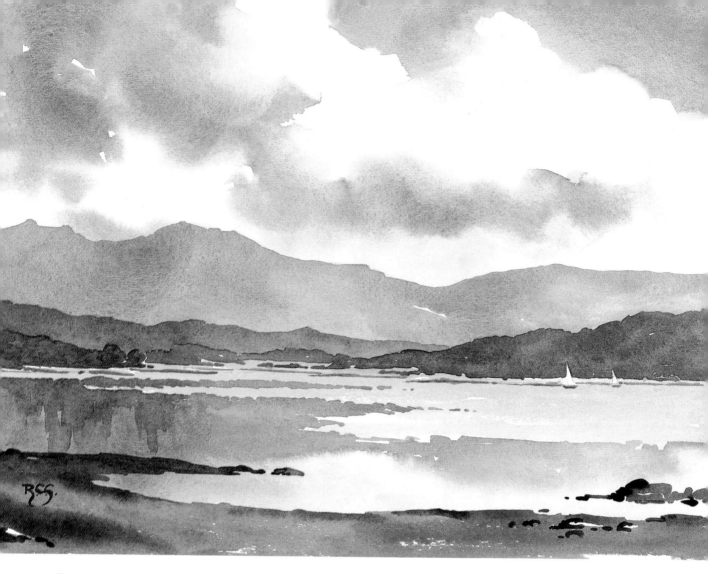

Derwentwater (10¾in × 14¾in)
*This is an example of a scene reduced to its essentials
and painted in a series of flat, variegated washes. The
backdrop of mountains comprises one wash to which
blue/grey has been added, wet in wet, to denote
shadow. The bands of distant woodland, painted
progressively paler in tone and greyer as they recede,
are single washes into which several different colours
have been dropped to provide variety.*

*The wind-ruffled water is a pale wash of blue/grey
while the smooth stretches reflect the colours above.
Even the foreground is a single brown wash to which
darker accents were added during the drying process.
This simple wash technique gives a painting a feeling
of peace and tranquility.*

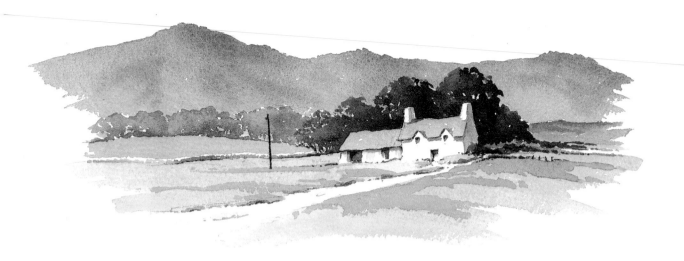

Loch Long, Wester Ross (10¾in × 16¼in)
The dark promontory makes a strong statement against a light patch of sky and the low clouds hide the higher peak to the right. Although the water reflects the grey of the sky, it appears pale against its darker banks. The white sail makes a crips note against the dark hillside.

The warm-coloured bush, to the right of the painting, prevents the eye sliding off the paper. The eye is, in fact, carried to the bend in the lock, to which the distant land forms appear to be pointing.

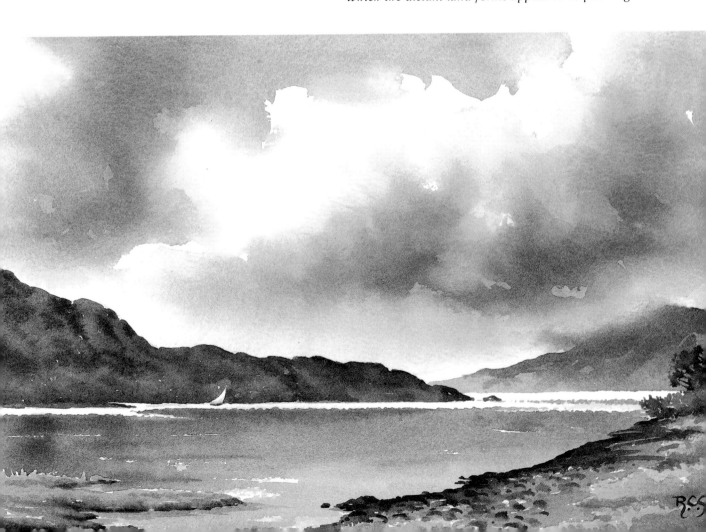

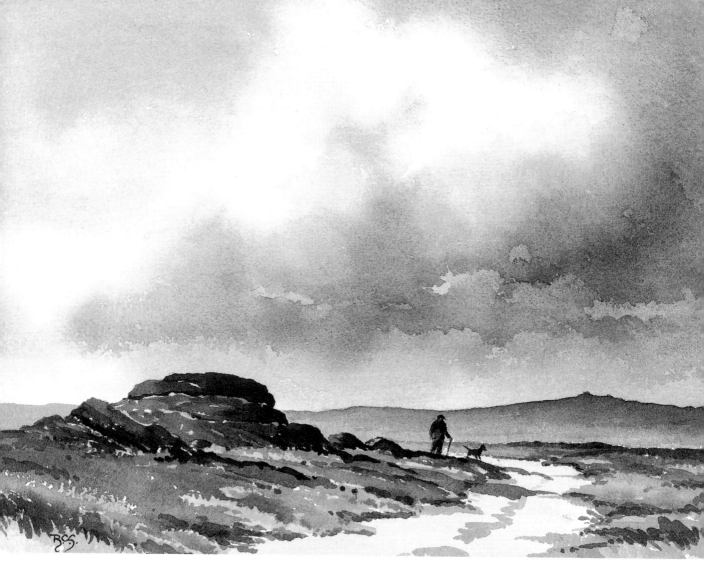

On Dartmoor (10½in × 14¼in)
Mountains do not have to be lofty to possess grandeur and atmosphere, as the weathered heights of Dartmoor demonstrate. In this moody impression the dark mass of the granite outcrop on the left is silhouetted dramatically against a light patch of sky and is balanced by the distant tor and the heavy cloud shadow on the right. Despite the sombre treatment of the scene, there is plenty of foreground colour in the moorland vegetation.

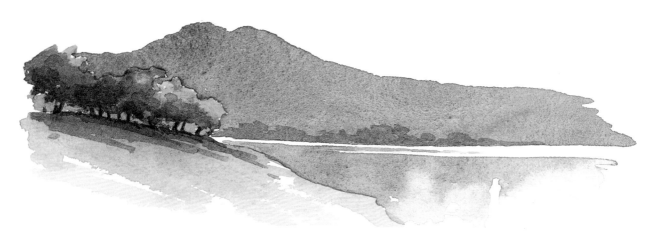

14
Buildings in the Landscape

Most art club exhibitions consist largely of rural landscapes and there are few paintings of the places where the members actually live. This is not surprising for as the urban sprawl spreads ever further, people need to remind themselves of the vanishing rustic idyll and feel that the rural scene is the proper source of artistic inspiration. A further consideration may be that attractive landscapes are more likely to appeal to potential buyers than impressions of the local supermarket. This is perfectly understandable and painters have a right to choose subjects that attract them. The danger is, however, that this attitude may lead them to ignore promising material on their doorsteps. So what can they do? They can train themselves to respond to stimuli of all kinds and learn to use their eyes and their imaginations more freely, to discover possibilities in unlikely urban subjects.

Straight rows of identical houses do not usually make appealing subjects, but groups of older, inner-city buildings are another matter and can provide intriguing compositions. Light and atmosphere have a big part to play and industrial landscapes silhouetted against glowing skies can have a compelling beauty of their own. *Railway Viaduct* (see page 58) and *Dockside Road* (see pages 97–9) are examples of the type of urban scene that has much to offer the watercolour painter. Lowry's vision of industrial Lancashire demonstrated how ugly factories and mean streets may inspire paintings rich in feeling and character.

Simple domestic scenes are another interesting but often neglected source of subject matter and many fine paintings have been made of suburban gardens, the backs of neighbouring houses, views from attic windows and so on. As with urban landscapes, what really matters is imaginative treatment and originality of interpretation. *Over the Garden Wall* (see page 90) is an example of a simple domestic scene of this type.

Buildings really come into their own in cities such as Venice, Bruges, Paris and London. Though insensitive planning has ruined much of the skyline of the two capitals, there are still superb subjects to be found there while there is hardly a canal in Venice which is not a painter's delight. Buildings also have an important part to play in rural landscapes. They can provide focal points and centres of interest and can contribute much to the character of the country scene.

Whenever possible avoid head-on, four-square compositions and look for oblique angles and contrasting planes of light and shade, for these can add greatly to the interest and attraction of a subject. The inexperienced often give more thought to the correct and exact outlines of their buildings than to their artistic appeal and some-

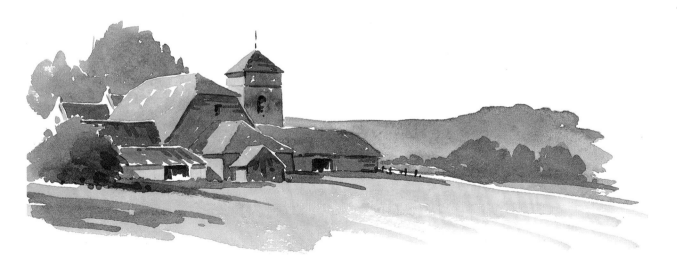

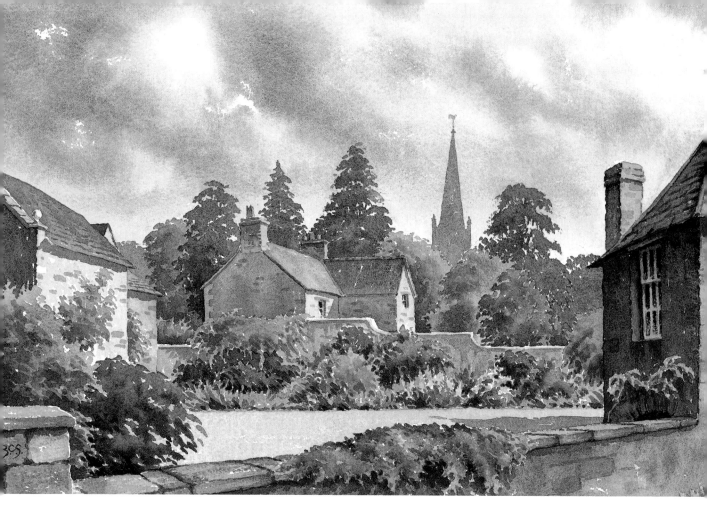

Over the Garden Wall (12¾in × 18½in)
This was painted one fine autumn day in my daughter's garden in the Cotswolds. The buildings, set at various angles, are an interesting blend of light and shade and their material is suggested by a few random blocks of honey-coloured stone. The church spire, offset to the right of centre, is just a grey silhouette. The trees show variety of colour and shape and provide tonal contrast with the stonework. The atmosphere is one of peaceful domesticity.

times even tidy up the wayward lines of old cottages and barns. Far better to exaggerate these signs of age and use them to give your buildings character. Of course, the basic structure and perspective of your buildings must be correct, but do not try to reproduce exactly every detail and every feature. A few random bricks or blocks of stone are sufficient to suggest the structure of a wall and you should be more concerned to show local variations in its colour, the effects of algae and weather-staining and, most importantly, the shadows falling across it. These are the things that really matter. This sort of treatment will be more telling than the meticulous painting of every brick and tile. Of course, these blemishes are more obvious with older buildings, but they are always there to some extent and it is up to the artist to discover them and do them justice.

Always look for colour in your shadows and never be content to paint them a flat, unrelieved grey. The inclusion of rich colour and the glow of reflected light add enormously to their appeal. Make sure, too, that you paint them in such a way that they reveal any unevenness of the surface on which they lie.

Chimneys and windows need more thought than they commonly receive. Chimneys are usually seen against a bright sky and should be painted in strong, dark colours to make the necessary impact. Window panes are often shown as uniform oblongs of dark grey. This is bad enough if there are just one or two in the painting, but when there are many more, the effect can be monotonous in the extreme. So study your windows, note the areas of reflected light, the tone and colour of curtains and other features and make sure that these variations are included or at least suggested.

Maldon Quayside (13½in × 10¾in)
This jumble of old buildings makes a pleasing pattern of light and shade. The church tower on the left balances the moored sailing barge on the right and the geometric shapes of the houses contrast with the softer forms of the trees. The overall warmth of colour suggests late afternoon light and unifies the painting.

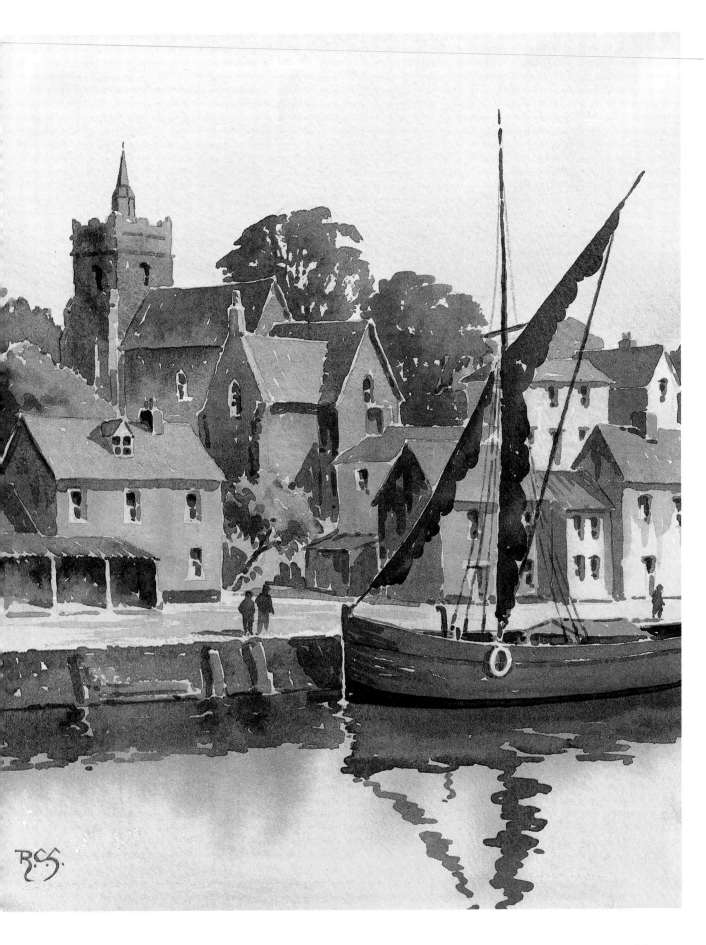

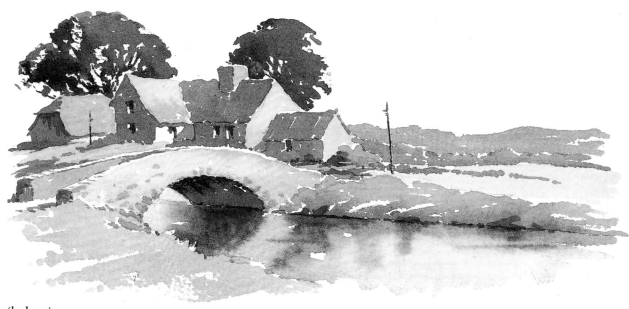

(below)
Grand Canal (2) (10¼in × 14⅝in)
*The object of this loosely painted impression of
Venice was to attempt to capture the special quality
of the light of that lovely city. The paper was allowed
to shine through the pale washes of sky and water
and the distant buildings were indicated in soft grey.
The foreground buildings were painted more strongly,
in warmer colours, and although they contain more
detail this, too, has been handled loosely.*

(opposite)
Sacré Coeur (14¾in × 11in)
*This much-painted corner of Montmartre was tackled
just as the sun emerged after a shower and the object
was to capture something of the sparkle of the Gallic
scene. The domes of Sacré Coeur make a pale accent
against the grey sky and the lights and darks of the
buildings and trees are reflected in the wet street.*

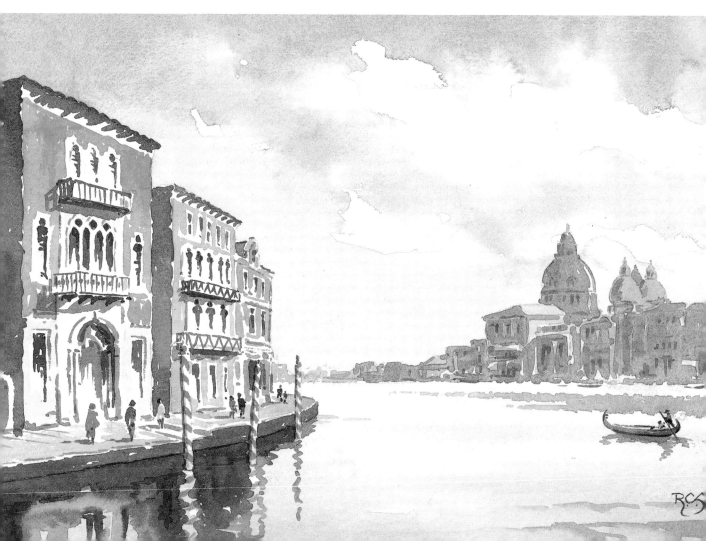

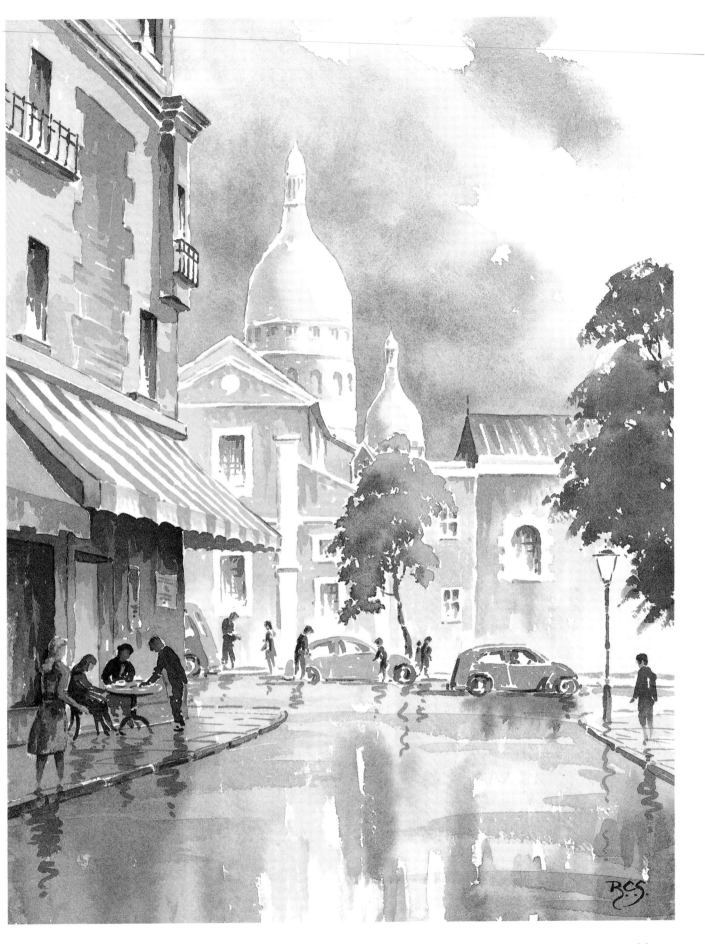

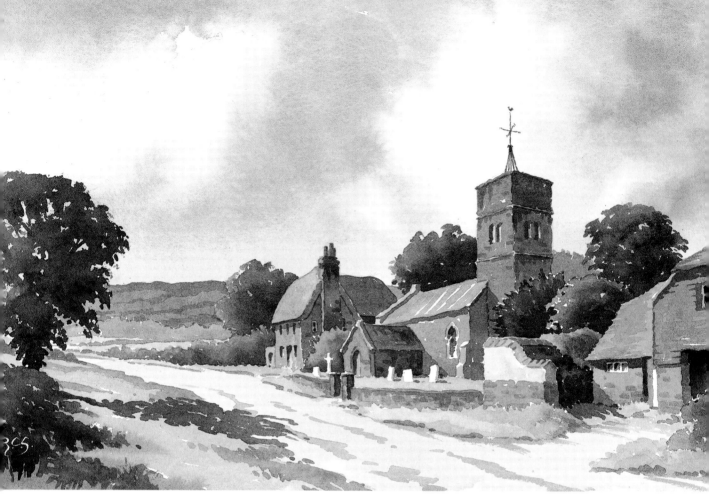

Dorset Village (11in × 16¼in)
*In this simple village scene the group of old buildings
fits naturally into the landscape and becomes an
integral part of it. The colours of nature find an echo
in the colours of the weathered building materials so
an overall harmony is established.*

Line and Wash

An interesting offshoot of watercolour is line and
wash. It is not suitable for every type of subject
and would be out of place in gentle, atmospheric
landscapes, but it comes into its own where
strong, positive drawing is required. It can be
used to particularly good effect for buildings and
street scenes.

The term 'line and wash' includes many dif-
ferent approaches. At one extreme a fine nib may
be used to produce a delicate line; at the other, a
blunt instrument, such as a shaped stick, may give
a stronger, more textured result. There are
various drawing instruments on the market which
produce a rather mechanical line of uniform
thickness and while these have their uses, flexible
nibs, which can produce both fine and strong
lines according to the amount of pressure used,
are far more expressive. The old-fashioned goose
quill is excellent in this respect, though more
difficult to control.

Village Street (8in × 9in)

The West Gate, Canterbury (7½in × 10½in)

*It is often useful to make quick, preliminary studies in
line and monochrome. In these two examples, a
flexible nib and varying washes of lamp black were
used.*

94

Old Houses, Penshurst (17in × 13in)
A good example of the type of subject that lends itself to the line and wash treatment. It is architectural, with bold forms and strongly contrasting lights and darks. A balsa stick was used to capture the rough textures of old beams, stones and tiles.

The composition enhances the shapes of the old buildings and the pale tones of the centre of interest – the glimpse of sunlit churchyard – are emphasised by the dark archway through which they are seen.

A sharpened stick of balsa wood makes a good drawing implement and can produce a strong, interesting line. Its absorbent texture enables it to carry more ink than a stick of ordinary wood, and as this begins to run out, a soft mark, more akin to charcoal, results. This softer effect can be enhanced by using quick, light strokes which skate over the surface of the paper. If you try this type of implement, remember to tackle the dark passages immediately after dipping it in the ink, and deal with the lighter ones as the ink begins to run out.

Waterproof Indian ink is normally used for line and wash work, though some artists find it too strong and prefer sepia, or something similar. A smooth (HP) watercolour paper is suitable if you are using a pen but a Not surface gives a more expressive and broken line if your preference is for a stick.

Once the ink drawing is dry, you can safely begin to paint. Avoid the use of harsh, bright colours which rarely look well in watercolour and never in line and wash. So use light red rather than vermilion and Payne's grey rather than ultramarine. Keep a balance between the two elements, line and wash: if your line drawing is too complete, there is little left for the wash to say, and the result is a coloured drawing. And if your line is free and bold, the wash should be applied in a similar manner so that there is harmony between the two.

15

Demonstration

Dockside Road (11in × 10¼in)
This simple urban scene relies heavily on atmosphere for its effect. The evening light casts a warm glow over the mean street and the sharp accents of the street lamps and lighted windows help to suggest the gathering dusk. Notice how the curve of the road is prevented by the foreground buildings from carrying the eye off the painting.

Stage 1 First sketch in the main construction lines of the composition and apply masking fluid to the street lamps and one upper window. Now pre-pare two washes, one for the warm upper area of sky, the other for the cooler, slightly darker lower part. Use raw sienna and light red, with just a touch of ultramarine for the first, and ultramarine and light red for the second. Starting at the top and using broad, horizontal strokes of a large brush, begin to apply the first wash. About one-third of the way down, start dipping the brush into the second wash, finally reverting to the first wash for the bottom third of the paper. This should produce a smooth variegated wash over your whole paper.

Stage 2 When the background wash is completely dry, start painting in the most distant buildings with a weak wash of ultramarine and light red, treating them as a pale, warm grey silhouette. With a slightly stronger wash of the same two colours put in the cranes and the middle distance building, adding a little raw sienna and light red to the area round the street lamp to suggest radiance. With a still stronger mix of the same colours paint in the curving wall and the fore-ground buildings, but this time add a little burnt sienna here and there to provide variety. When everything is thoroughly dry, remove the masking fluid and paint the resulting white shapes with very pale yellow but use some warmer colour for two of the first-floor windows.

Add a little weather-staining and texturing to the brick walls and paint in the dark accents of the window frames and shadowed areas. Paint the dock gates with dull green, leaving rectangles for the posters.

Stage 3 Complete the painting of the foreground buildings, using combinations of the same colours. The roadway and pavements are wet from a recent shower and show soft reflections of the objects above. Paint a weak wash of raw sienna, light red and a little ultramarine over the whole area and while it is still wet apply vertical strokes of the appropriate colours: raw sienna and light red under the shop window, ultramarine and light red for the darker reflections and so on. When all this is dry, put in the lines of the kerbs, a few lines suggesting the edges of the paving stones and some vague curved lines to stand for wheel marks in the wet road. The darker accents go in last: the lamp posts, a few darker reflections and the little figure against the lamp-lit wall.

Stage 2

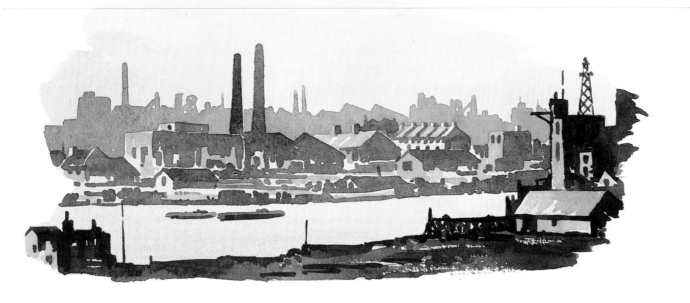

Stage 3

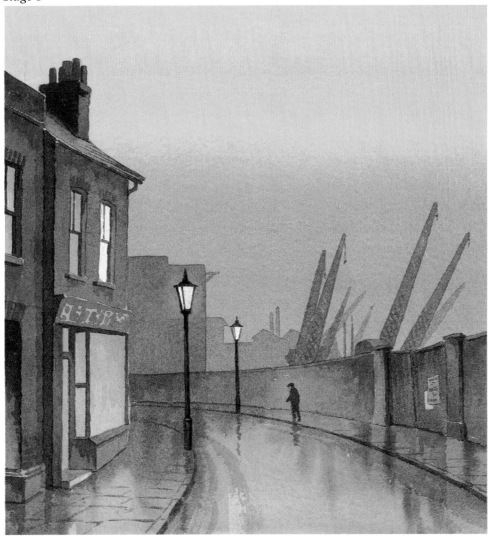

16
Waterscapes

Rye Harbour (10¾in × 14⅝in)
There is a lot of detail in the old harbour scene and this is an instance in which any attempt to paint a mirror image would have led to an over-complicated result. Soft reflections were the answer and these were put in with vertical strokes of large brushes dipped in pre-mixed washes of the appropriate colours. Again, pale stretches of wind-ruffled water conveniently separate land from sea. The foreground reflections of the baulks of weathered timber and the old hulk on the right of the painting were put in boldly with a wash of sludge green (Payne's grey with raw and burnt sienna).

Many students experience difficulty painting water and often play for safety by avoiding subjects in which it occurs. This is a mistake because water can add an extra dimension to the landscape and impart a sparkle to an otherwise drab scene. The shine of a river meandering across a flat plain or even the waterlogged ruts of a muddy farm track, reflecting the bright sky beyond, can make a dull landscape scintillate. The horizontal plane of river and lake can also provide a useful foil for the more vertical forms of nearby trees and buildings.

Of course, painting water presents all sorts of difficulties and complications. You only have to imagine trying to paint a stretch of water where

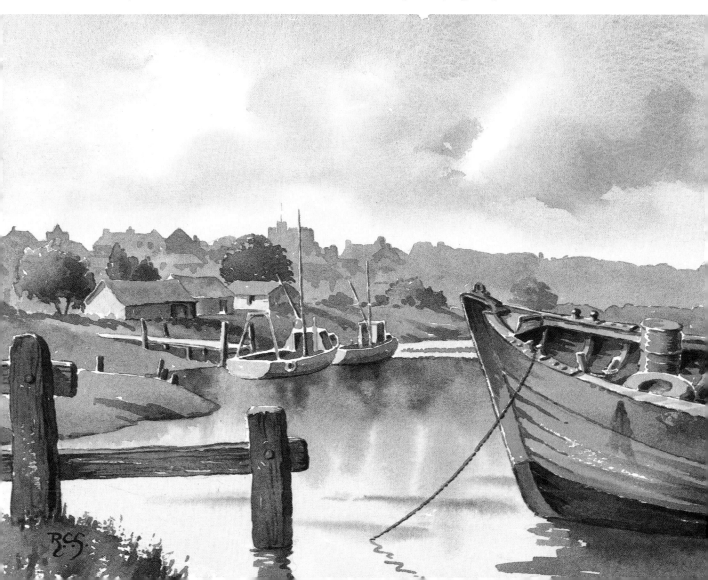

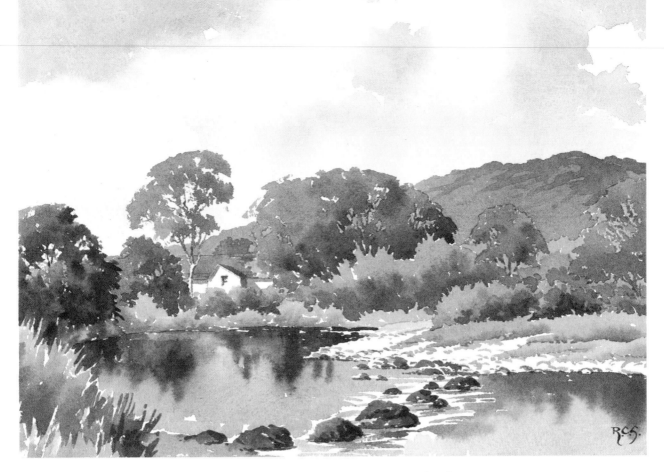

the bed and the reflections intermingle to appreciate the sort of problem that can arise. Reflections can present a number of difficulties. They may, for example, be broken up by innumerable tiny ripples and form a pattern far too complex for any loose watercolour technique. They can form excessively complicated mirror images which can not only lead to over-elaborate compositions, in which land and water compete for attention, but also, by their very complexity, can make a bold approach virtually impossible. All this may sound very daunting and likely to discourage the faint-hearted still further, but do not despair, these are all problems that can be solved or at least circumvented. You can, for a start, choose places where the water will respond to a bold treatment and avoid those that present particular difficulty.

In earlier chapters, the problem of the mirror image was considered and suggestions made for softening it in certain circumstances. A complex scene can become confused if an equally complex reflection is painted beneath it, but a softer treatment of the reflection can provide a welcome contrast. Much the same solution may be applied to simplifying the effect of an impossibly large number of minute ripples. In both cases the water may be looked at through half-closed eyes in order to lose detail, and the softer image which

The River Wharfe (10¾in × 14⅜in)
The movement in this Dales river showed itself where the water flowed past the rough stepping stones. The unevenness of the disturbed surface was caught by the light and has been indicated here by unpainted chips of white paper. These could have been preserved by the use of masking fluid. Where the water was less confined and deeper, it appeared smoother and produced soft, vertical reflections. These contrast in tone with the lighter foliage and the bleached limestone pebbles beyond, to produce a clearly defined edge to the river.

(overleaf)
Bend in the River (15¼in × 21¾in)
With the exception of the rough foreground grass on the left, the water in this painting was put in last, so helping to ensure that the reflections were correctly placed. An errant breeze ruffled the more distant stretch of water and this disturbance of its surface is represented by two narrow bands of pale blue-grey. The nearer water was smooth enough to show soft reflections, but not mirror images, of the trees above. Several full washes were prepared in advance for the reflections of the light clouds, the cloud shadows, the distant hills, the reeds and the trees. These washes were applied with vertical strokes of large brushes, the paler colours first. The darker accents were added last with a stiffer mix of dark green (Payne's grey with raw and burnt sienna). The paint was applied quickly so that the washes merged together to produce a soft-edged result.

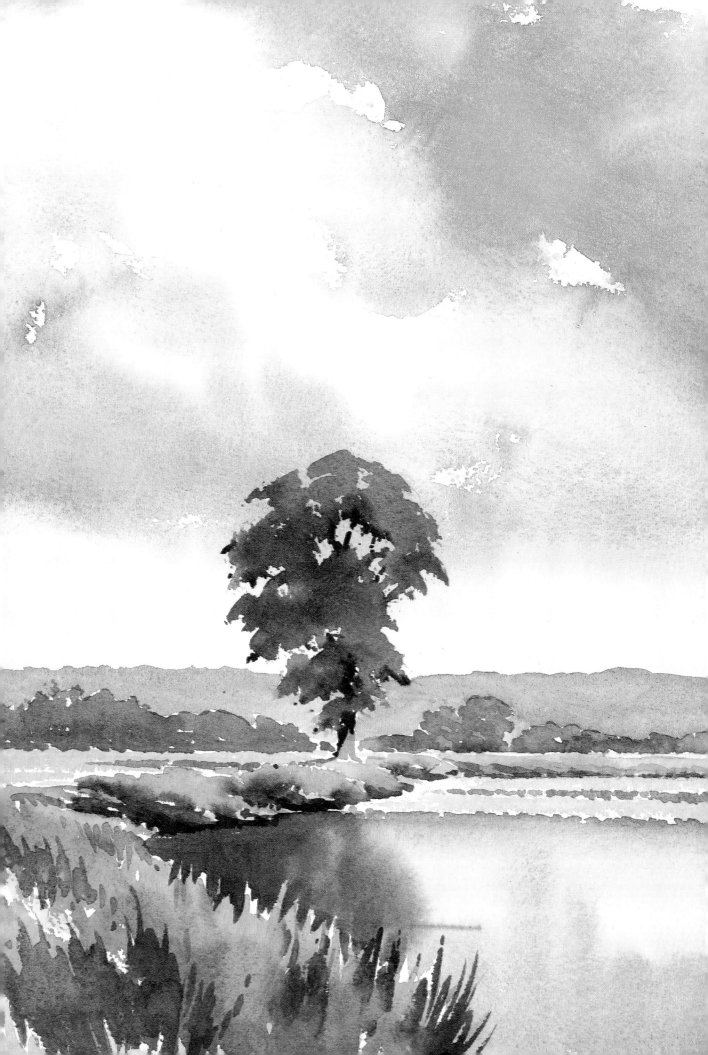

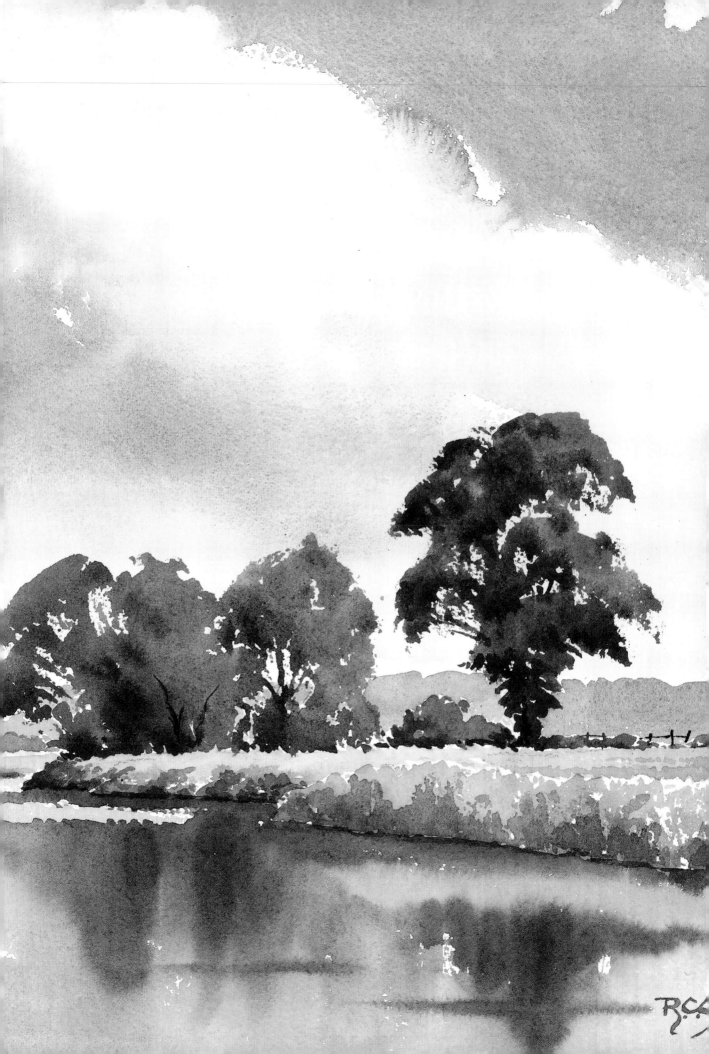

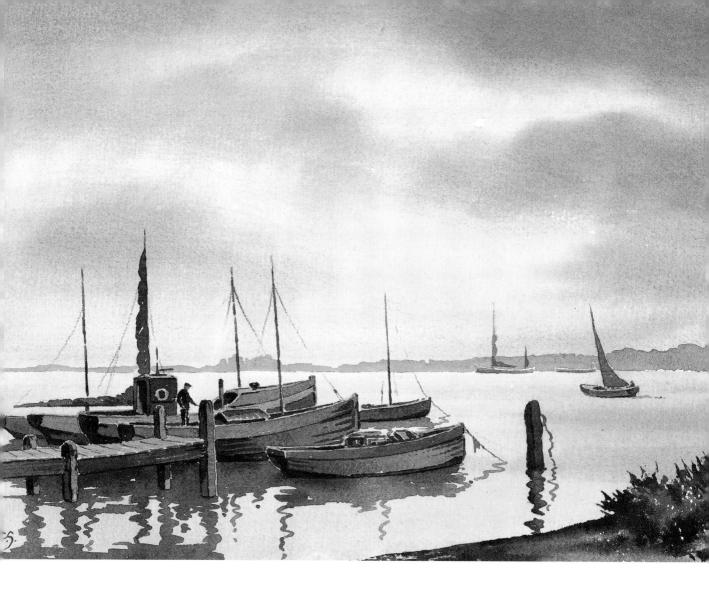

Landing Stage, Walberswick (10¾in × 14½in)
The sky and the water were painted together in one pale, variegated wash and while this was still wet, soft clouds and cloud shadows were added in a warm grey (ultramarine and light red). When this was dry, the far bank was painted in a single wash of the same grey and the boats and landing stage were added in deeper tones and a variety of colours. The near reflections were a uniform grey-green and were put in with a single wash of Payne's grey and raw and burnt sienna. Finally the dark foreground was added and this helps to balance the composition.

results painted boldly and loosely. This simple expedient alone will, with practice, solve many of the problems associated with painting water.

Watercolour is at its best when used loosely and freely and nothing should be allowed to cloud its freshness and purity. This means in practice that it should be used quickly and boldly and this, in turn, requires the omission of much irrelevant detail. How, then, should you go about painting a stretch of water? The first step is to study your subject thoroughly and analyse it carefully. The second is to plan how you are going to simplify it and decide what inessential detail you can omit. The third is to study the tones and colours of your subject and prepare suitable washes. Only then, when everything is ready and you have planned your strategy, should you begin to apply paint. The painting process should be carried out as planned and as swiftly as possible. Changes of mind in mid-wash and attempted alterations will mean loss of freshness, so stick to your guns and carry your plan through to fruition. If there are mistakes, let them be bold and fresh, not timid and muddy.

Moving water requires even more careful planning, for here the reflections are broken up

Dorset Mill (8¾in × 11¾in)
Though many water mills were built in the early days of the Industrial Revolution, few remain in their original state. This example from Dorset is a fortunate exception. The shape of the building is a simple one, but the oblique angle gives added interest. The deep tones of the bank of trees contrast with the paler tones of the mill, and the trees themselves contain colours other than green.

by surface indications of that movement. These can sometimes be represented by horizontal chips of white paper left during the application of the initial wash or preserved by the use of masking fluid applied with discretion. These and other techniques are described in more detail in the captions in this chapter.

(overleaf)
Dartmoor Stream (10¾in × 14¼in)
This rushing stream, flowing down from the high moors, presented a very different problem, that of conveying a powerful feeling of movement.

The sombre mood of the brooding moorland setting had to be established first. The clouds were fast-moving cumulo-nimbus, put in with pale raw sienna for the lighter areas and fairly strong ultramarine and light red for the shadows. These washes were softened here and there but given some hard edges to represent the ragged outlines of the clouds.

The stark expanse of distant moorland, all in cloud shadow, was a single, deeper-toned wash of the same grey, plus a little more ultramarine, and its

uncompromising outline helped to establish the mood of the painting. More light red was added for the purplish moorland in the middle distance. The nearer banks of the stream were made up of wet rock, tawny grass and several types of moss and lichen and these were painted boldly with various washes of green, brown and tan. The deep tones of the rock were emphasised to provide contrast and make the water shine.

The peaty colour of the stream was very evident as it tumbled over a rock ledge in the foreground and for this a wash of burnt sienna, light red and a little ultramarine was used. This was applied loosely with the side of a no 10 brush, and rough arcs of white paper were left to suggest foam in the downward curving sweep of the cascading water. Before this wash had dried, its lower edge was softened with clear water to suggest foam and spray and this was given form by the addition of some pale blue-grey shadow. The water above the cascade was painted in pale tones with horizontal strokes of the brush, with plenty of paper left untouched to suggest foreshortened stretches of white water.

The treatment throughout was bold and uncom-promising, to match the rugged nature of the subject.

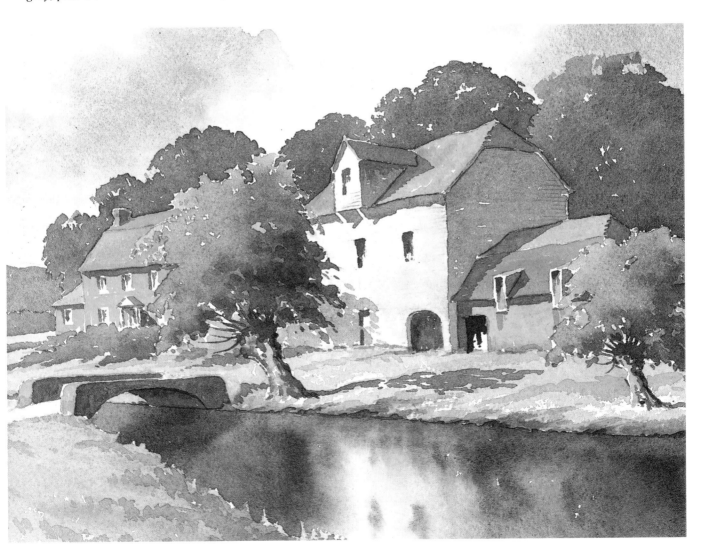

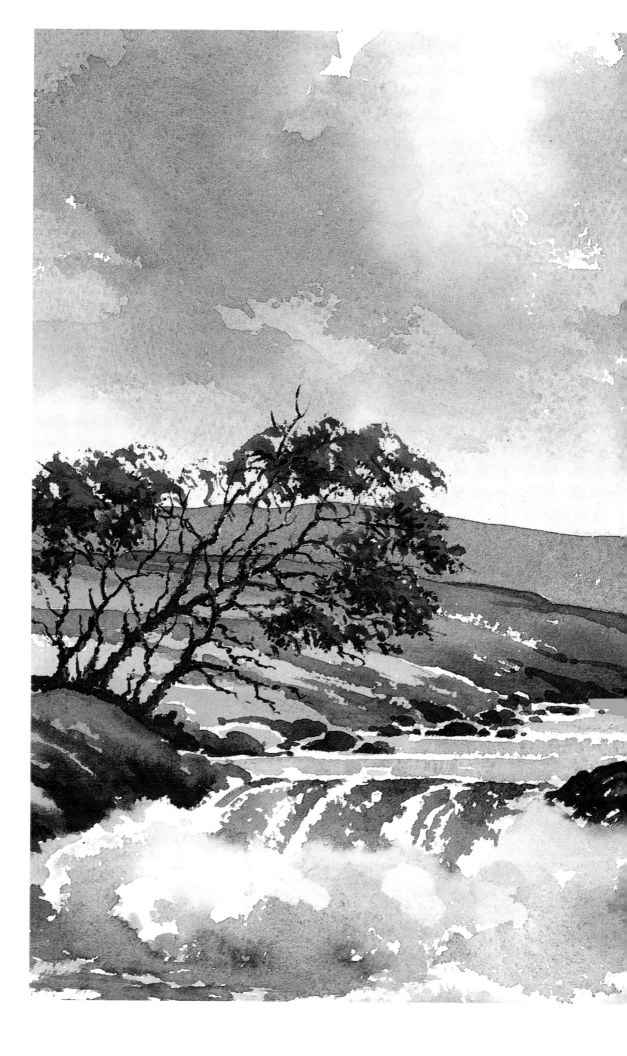

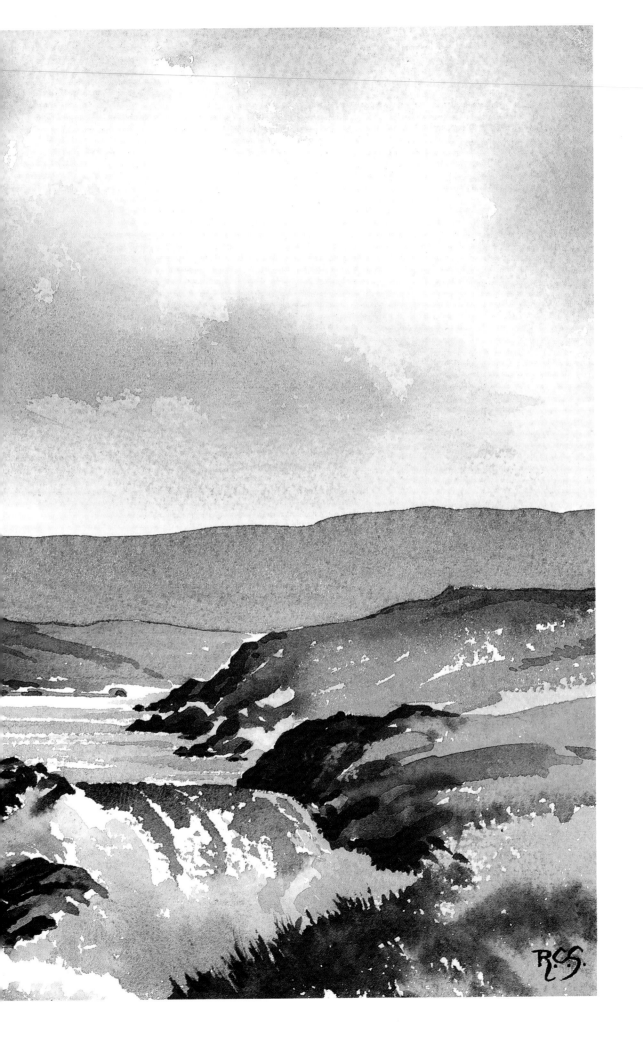

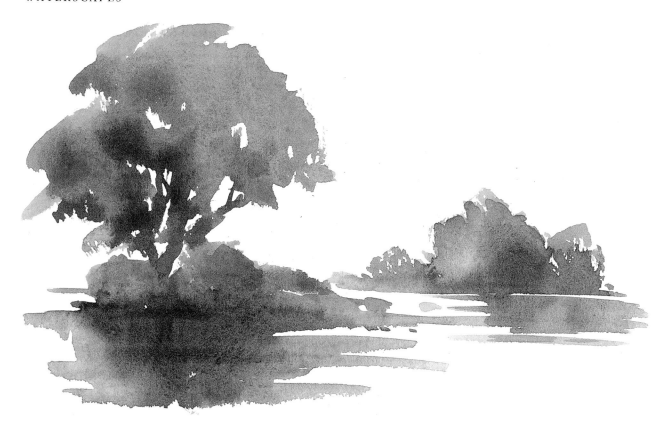

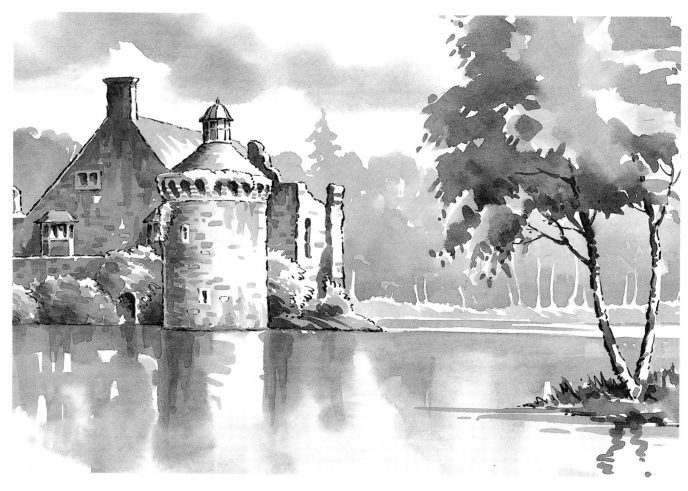

17
The Coastal Scene

The margin between land and sea has an appeal for almost everyone, an appeal which has its roots, perhaps, in happy memories of seaside holidays long ago. Whatever the origin, the shoreline and all that goes with it has a special place in our affections and this is particularly true of painters. The coastal scene is rich in subject matter and atmosphere: bustling harbours, busy boatyards, rugged headlands, broad expanses of sand, misty seascapes and many more are subjects that have appealed to artists of all eras, as our artistic heritage confirms, and will continue to provide inspiration.

There are too many areas where man's activities have destroyed this beauty, but there are others, happily, where they have enhanced it. In Cornish fishing villages, for example, cottage and harbour walls are solidly built of local stone and seem to be extensions of the living rock. Even ramshackle fishermen's huts, surrounded by nautical clutter and old boats, provide a rich feast for the perceptive painter. The important thing, as with so much in painting, is to concentrate on

mood and feeling and include only that detail which has something positive to contribute.

The sky has an even more important part to play in seascape than it has in landscape painting, for water is far more reflective than land and reacts more strongly to light and colour. So consider sky and sea together and make sure they are in harmony. The flatness and emptiness of the open sea makes you more aware of the sky above and if this is a dramatic one it may well be worth featuring by the adoption of a low horizon.

A common fault in painting seascapes is to include too many waves and we have all seen paintings in which the regular wave forms stretch away in serried ranks almost to the horizon, looking for all the world like green corrugated iron. It is far better to concentrate on no more than two or three waves and merely suggest the others. When painting the sea from the shore, remember to include the wet patch of sand left by the last retreating wave; this will be darker in tone and more reflective than the dry sand. The lines of seaweed or flotsam left by the tide are also

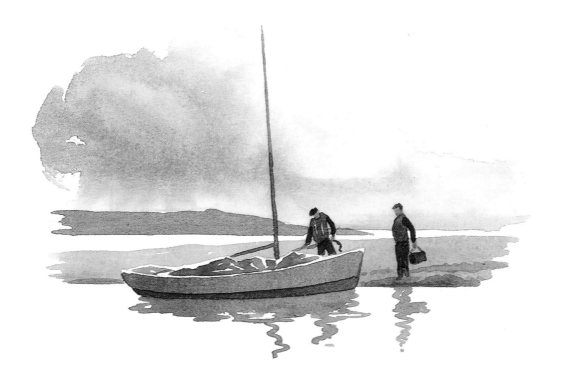

Dungeness (12in × 18¼in)
An example of a low horizon with a lively sky occupying over three-quarters of the paper. The loosely painted sea features just one wave form, with the merest suggestion of two more behind. The wet strip of sand and the hint of a 'flotsam line' help to describe the curve of the shoreline. Dry-brush work has been used to suggest foam on the left and shingle on the right of the painting.

worth putting in for they follow the curving line of the shore and help both composition and perspective. This applies with particular force if you have adopted an oblique viewpoint and are not looking straight out to sea.

Always bear in mind that the higher you are above the sea, the greater will be the distance to the horizon. I remember reading somewhere a rule of thumb to the effect that the distance to the observed horizon in nautical miles is roughly equal to the square root of the height in feet of your eye above sea level. I do not include the table of square roots in my painting haversack and have not been able to verify this rule, but it is clear a direct relationship exists!

Boats are a vital part of the coastal scene and can add greatly to the interest of a painting. They come in all shapes and sizes from pleasure yachts with their sleek and elegant lines to beamy old

fishing craft with their solid, uncompromising shapes. Boats are notoriously difficult to get right; viewed in profile there is no particular problem, but at an oblique angle the subtle curves of hull and gunwhale demand close observation and careful drawing.

Rigging is another problem and the best advice here is to leave out all but the principal and most obvious ropes and even these may be the better for being merely suggested. The inclusion of every rope in sight is a recipe for disaster, and the craft in question will end up looking like the proverbial cat's cradle. How you actually tackle ropes will depend largely upon your watercolour style; if your approach is fairly loose, accurately painted rigging will be out of place and quick, broken lines will look better. Lines of rigging are usually seen against the sky so any errors are virtually impossible to correct, so practise on scrap paper until you are confident you have mastered the effect you want.

Coastal scenes can benefit greatly from the inclusion of well-placed figures so here too it is worthwhile cultivating the sketch-book habit so that you have material to press into service when you need it. Children playing on the sands and fishermen tending their boats are not always available when you want them and this is when a well-stocked sketch-book can come to your aid.

Quick figure studies are fun to do and regular practice will sharpen your observation and improve your technique. Even a lonely stretch of coast can sometimes do with a figure or two to give scale and provide a focal point and a sandy shoreline can be given extra interest by the inclusion of children building sand castles or fishermen digging for lugworms. In bright conditions there is great radiance over the sea and figures will appear very dark against it. So use deep tones and these will help to make the water shine.

Rocks along the shoreline need more careful observation and treatment than they often receive and are sometimes made to look like shapeless lumps of brown putty. Even when smoothed by the action of tides they have a distinct structure which derives from the underlying stratum of the original rock mass. This often shows itself in parallel faults, fissures and lines of weakness. These are constantly attacked by the waves and a definite, if random, pattern results. Their colour will, of course, depend upon the type of underlying rock and will be modified by seaweed.

Coastal scenery provides a wonderful diversity of subject matter for painters of all tastes and techniques. Subjects such as boatyards and harbour scenes call for a considerable amount of detail. Others, consisting of sea, sand, sky and little else, are tailor-made for quick watercolour studies and it is with these that the medium is perhaps at its best and most expressive. Misty conditions, when sky and sea merge, can inspire the watercolourist to produce paintings rich in atmosphere and mystery.

Norfolk Fishing Boats (10⅝in × 16¼in)
These venerable, clinker-built hulls, which now boast more modern superstructures and radio equipment, and still fish the North Sea in most weathers, were moored in a sheltered tidal inlet. They were carefully drawn and rapidly painted with plenty of tonal contrast. The calm water was a broken wash of pale blue-grey applied with quick horizontal strokes of a large brush. When this was dry the pale reflection of the far bank was added and the much stronger foreground reflection put in with a deep wash of grey-green. While this was still wet a little dark grey, red and blue were dropped in to provide local colour.

111

Children on the Beach

B.C.S.

Shrimpers (10⅞in × 14½in)
The deep tones of the two figures register strongly against the pale treatment of sea and sky. A spent wave and a strip of wet sand occupy most of the foreground. Only one wave has been given any prominence though several more have been broadly indicated.

The sky is a pale, variegated wash, shading from pale blue to warm yellow at the horizon. A distant cloud shadow and a slightly firmer treatment of the wave forms on the right help to balance the figures and their reflections.

The dark accents of the figures impart a shine to the backdrop of sea and sky and this is what the painting is really about.

(overleaf)
Beached Fishing Boats (13¾in × 19¾in)
A favourite theme, this, of solid, wooden fishing boats drawn up on a shingly beach. Once again, a low horizon gives full scope to a strongly painted cloudy sky. The deep tones of the boats and the winch make a strong statement against a luminous patch of sky. The clutter by the boats and the foreground shingle have been painted quickly and loosely in deep tones that also contrast with sea and sky. A similar subject to Dungeness but a very different treatment.

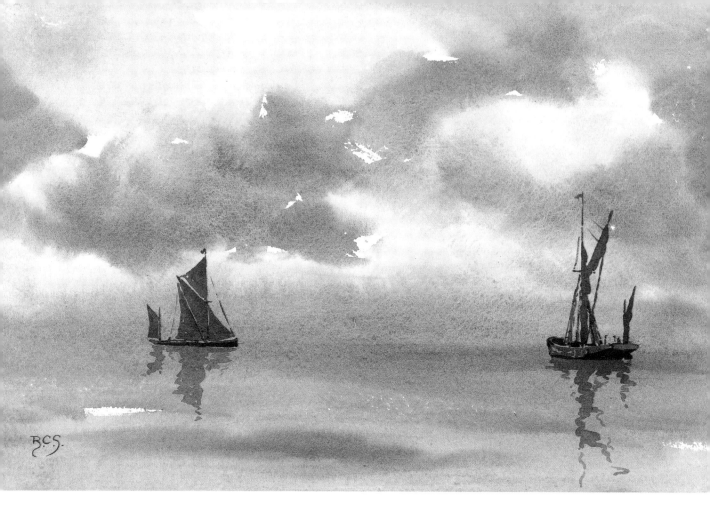

Lost Horizon (10¼in × 15¾in)

The soft clouds, the mist-obscured horizon and the calm sea combine to produce a feeling of tranquillity and the restrained use of colour reinforces this atmosphere of peace.

Three liquid washes were prepared, the first of raw sienna slightly warmed with light red, the second of ultramarine and light red and the third of Winsor blue with a little raw sienna. The wash of pale raw sienna was applied first, with a 1in brush, and the cloud shadow added with a second large brush dipped in the wash of warm grey. The third wash of pale Winsor blue was applied with broad, horizontal strokes of another 1in brush to represent the sea and to this several touches of the warm grey were added. All this was done in a matter of seconds, painting wet in wet, and the paper allowed to dry.

All that remained was to paint in the two old sailing barges, one in full sail to catch the light breeze, the other at anchor, and add their greenish reflections in the calm sea.

Digging for Lugworms

18
Atmosphere in Watercolour

For the landscape painter, mood and atmosphere are largely determined by the weather and by the quality of the light. Mist and fog, by softening outlines and obscuring detail, can lend an air of mystery, and sometimes of magic, to a mundane scene. The presence of grey cloud can establish a sombre mood while dark and lowering storm clouds can create an atmosphere of menace and doom. Sunlight has the opposite effect and evokes a sense of happiness and well-being. Between the extremes of violent storm and tranquil sunshine is a whole range of atmospheric effects for the artist to study, to analyse and to interpret. He should always be keenly aware of the quality of the light and its effect upon the landscape, for these are the main ingredients of mood and atmosphere in painting, and everything else should be subordinated to them.

A loose style of painting which suggests the subject matter instead of describing it in exact and literal detail, helps considerably in the creation of atmosphere. It leaves something to the imagination and when people's imaginations are stirred, they supply their own answers to the questions the painter has left unanswered. They will react differently and the individual's imagination will fill the gaps in different ways. This does not matter provided the painter has succeeded in striking a chord and in touching their emotions. Subject matter also has a part to play in building atmosphere but it is a subordinate one and the effects of light are dominant.

In this chapter we shall consider the moods which result from various types of atmospheric and light conditions and find out how they may be most effectively created by the watercolourist. Some of this advice has already been offered in a slightly different form in the chapter on skies, but it is at the heart of the landscape problem and bears repetition and emphasis.

Watercolour is the perfect medium for capturing the subtle effects of mist and fog. Painting wet in wet produces the blurred images and the soft outlines that such conditions demand, where detail is unimportant and mood is everything. The more distant the objects, the more they will be softened by the intervening atmosphere and if this effect is faithfully reproduced, a strong feeling of recession will be created. The immediate foreground, where the influence of the mist is

Moored Dinghy (9¼in × 13in)
The early morning light which flooded the estuary was the inspiration for this quick impression. While the pale, variegated wash of the sky was still wet, the distant shoreline was painted, wet in wet, to capture its misty outline. The nearer land form on the right and its reflection were added in stronger, warmer colours when the sky wash was almost but not quite dry. The moored dinghy, in deep grey silhouette, and the deep-toned foreground were added last, and, by contrast, impart a shine to sea and sky. The soft-edged grey of the distant land strongly suggests recession.

minimal, can be painted sharply and crisply and will create a dramatic contrast with the mistiness of more distant forms.

Mist is rarely given credit by beginners for possessing any colour of its own and is frequently painted a pale and indeterminate grey. While this can be true in certain conditions, mist often has a suggestion of warmth about it, particularly in urban areas, and can also possess a range of subtle pearly colours. These are well worth seeking out and will add greatly to the truth and the appeal of your work.

The wet-in-wet technique demands a sure

touch, quick execution and correct timing, and these will only come with practice. Once washes have been applied they should be left alone for any attempted modification, once the drying process has begun, invariably spells disaster. If some alteration is unavoidable, wait until the washes have thoroughly dried, then wet the area with clear water and apply more paint as necessary. This must be done with the lightest touch to avoid disturbing the earlier wash.

When painting clouds, always allow for the inevitable fading that occurs on drying. What, in liquid form, may look impressive and menacing, may well dry out to look tame and anaemic.

Woodland Walk (14¼in × 10¾in)
The object of this painting was to capture the effects of soft sunlight filtering through the misty foliage of an autumn wood. The luminous patch of sky was palest Winsor blue and raw sienna and while this was still wet, a warm grey of ultramarine and light red was painted, wet in wet, to suggest the surrounding misty foliage. Warmer greens and browns were added to the grey for the nearer masses of foliage. The sunlit areas of the tree-trunks on the left were preserved with masking fluid. The figures were added last to provide a focal point.

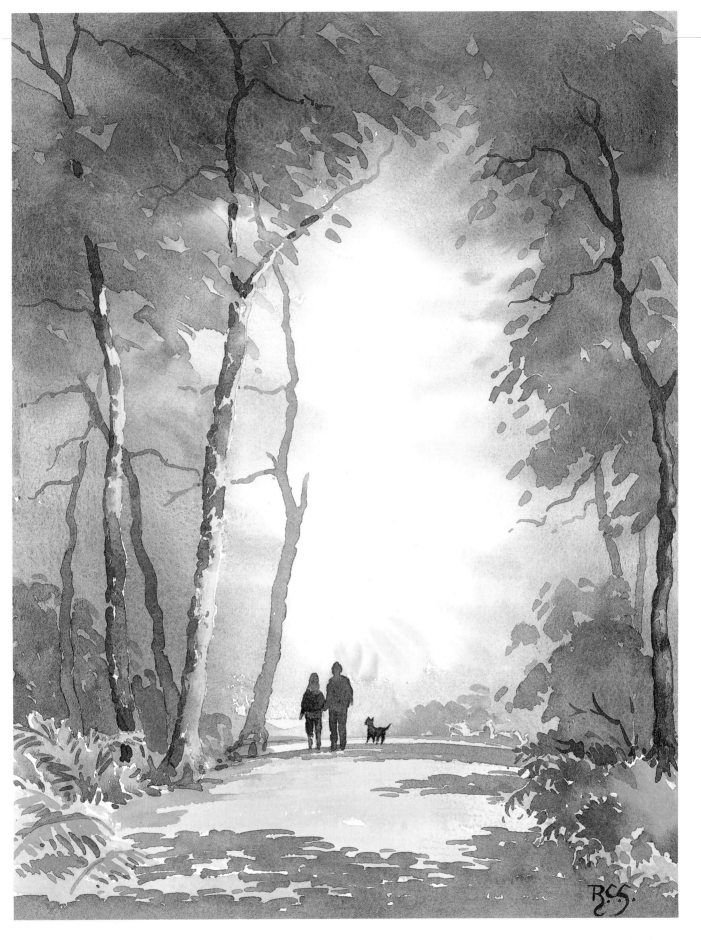

The Coffee Stall (10⅛in × 13¾in)

This is a mood painting of a very different kind in which the object was to capture the misty, drizzly atmosphere of an inner city scene by night. Only three colours were used: ultramarine, light red and raw sienna. Pale raw sienna was used for the areas of radiance round the street lights and, warmed here and there with light red, for the lit house and shop windows. Various mixtures of ultramarine and light red were used for the murky sky and raw sienna was added for some of the houses and the brick viaduct. The tone and colour of the old brickwork have been varied to provide interest and the material has been indicated by the painting of a few random bricks.

The diagonals of viaduct and roadway provide a more pleasing composition than a four-square arrangement would have done. The reflections in the wet road are a mixture of hard and soft edges. The figures were placed against patches of light to provide tonal contrast.

While it is always possible to add strength by applying a second wash, the result will never be as lively and impressive as a strong initial wash. Boldly painted clouds and their equally bold shadows on the land below can add enormously to the power and the atmosphere of a landscape. A cheerful summery atmosphere is created by tiny puffs of white cloud in a blue sky while the smooth, level layers of stratus cloud generally produce a calm and peaceful mood, as do most horizontal forms.

Rain squalls, particularly when they occur over mountain or sea, can add to the interest and the character of a painting. They are best described by slanting, soft-edged strokes of a broad brush, from the base of a dark cloud. Attempts to paint individual drops of rain by a succession of oblique lines are rarely successful.

Always assess carefully the temperature of the light which can be warm on the coldest of days and analyse the quality of the sunshine: is it bright and strong or weak and watery? Is it warm or cold, clear or misty? The answers to these questions will vitally affect the mood of your painting.

An overall glaze can sometimes pull a painting together, particularly in cases where the sky and the land do not seem to be entirely in harmony. A warm-coloured wash applied over the whole paper can provide a unifying glow, but a word of warning here: the operation must be carried out quickly and gently or the underlying painting may be disturbed. Earth colours, particularly when used heavily, are the most vulnerable to disturbance by glazing washes of this kind.

The effects of light falling on the landscape need careful consideration, especially on days when there is much broken cloud. If these areas of radiance are distributed widely, they can produce a patchy, disjointed effect and it is usually better to concentrate them in one area which could be your centre of interest.

Light and shade are the twin keys to atmosphere in the landscape and if you do them justice they will add immensely to the success of your painting.

Early Shift (9¾in × 14¾in)
The atmosphere of this quick watercolour sketch relies mainly on the subject matter: a damp and cheerless early morning scene in which a lonely, hunched figure pedals doggedly towards the distant factory. This mood is reinforced by the loose, watery style of the painting and by the muted colours which suggest the 'cold, grey light of dawn'. The misty atmosphere is established by the progressive lightening and greying of the buildings as they recede into the distance.

(overleaf)
Near Shap Fell (10¼in × 10¾in)
This painting illustrates some of the points made in the text. The heavy cloud mass on the left looked altogether too dark while it was wet, but, as expected, it dried out about right. A loose, diagonal wash from its base suggests an approaching rain squall and the deep tones of the cottages and foreground register strongly against the bright patch of sky and make it shine.

Notice how the low horizon focusses attention upon the strongly painted sky which determines the mood of the painting.

121

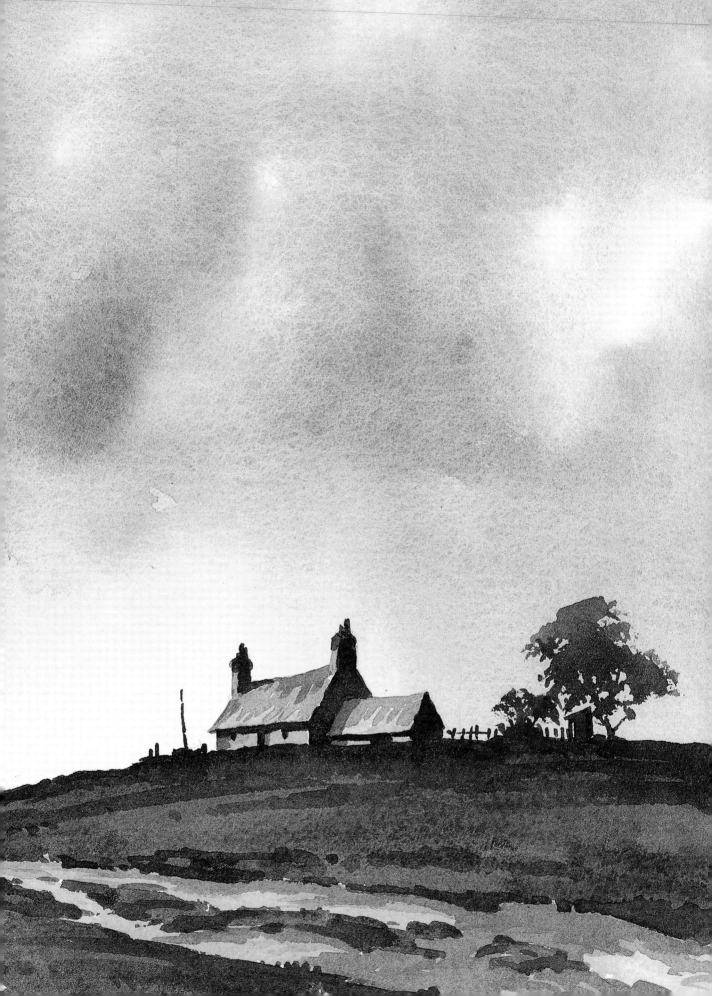

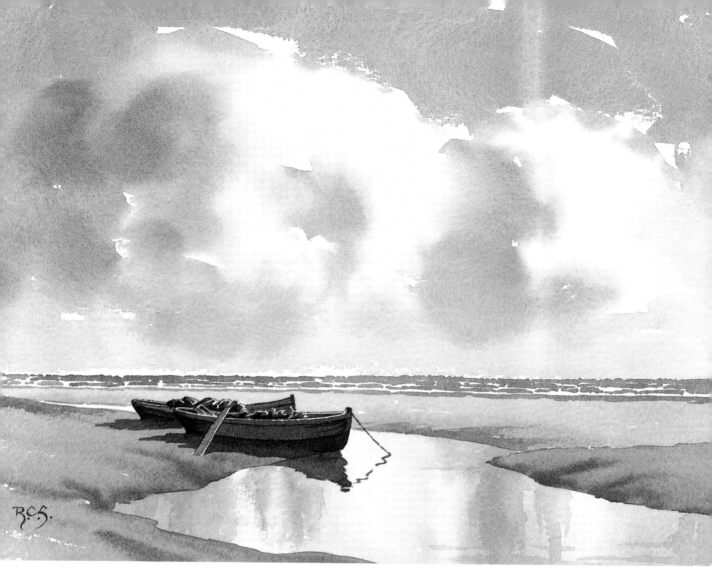

(above)
Lonely Shore (10½in × 14⅜in)
The mood engendered by this painting stems largely from its theme – two boats against a deserted shore – and from the treatment of the subject matter. The boats, deep-toned against a pale background, emphasise the emptiness of the scene while the horizontal composition and the smooth foreground water reinforce the feeling of peaceful isolation.

In Conclusion . . .

Most students long to develop a distinctive style of their own and sometimes set out deliberately to acquire one, perhaps by imitating the mannerisms of established painters. This is a road that leads nowhere. It is far better to let your style develop naturally, as it will do in time. We are all influenced by the work of painters we admire and our own painting is bound to reflect this, but that is a very different thing from consciously trying to reproduce their manner of painting.

Style is an amalgam of many things: the way we put on paint; the colours we use; the sort of compositions we prefer; and in the last resort reflects the way we see our surroundings. So be true to your vision of the world, paint in the way that is natural to you and in time a genuine style will develop.

Bon voyage!

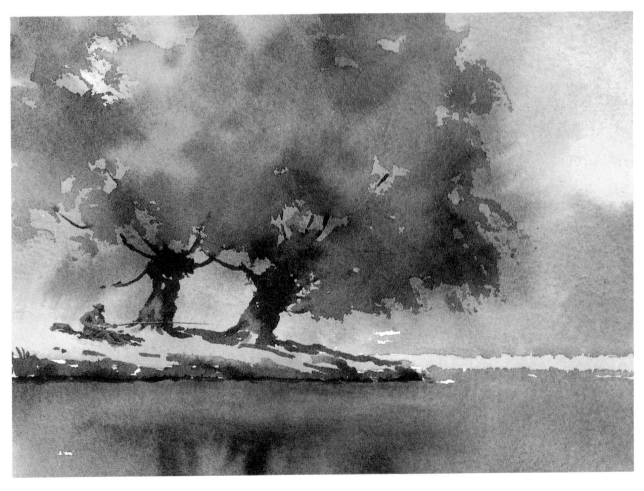

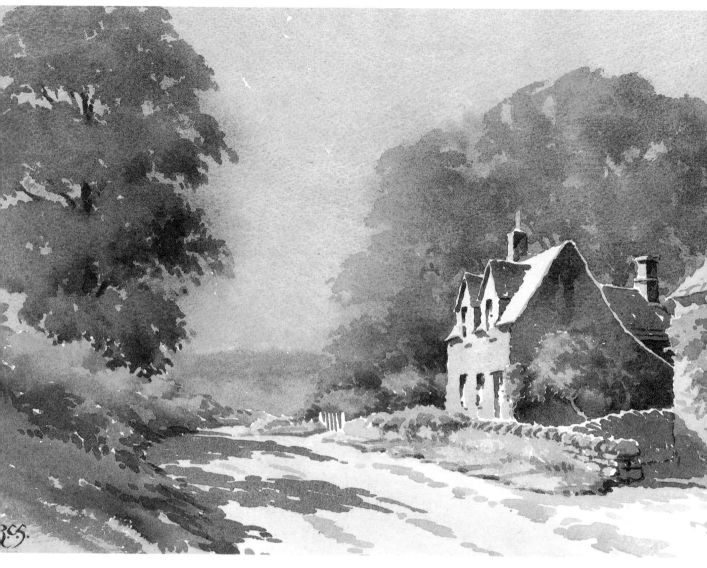

Autumn in East Leach (10½ × 15in)

Acknowledgements

I would like to thank my editor, Faith Glasgow,
for her help and advice; Maureen Gray for
converting my scrawl to orderly typescript;
and my wife Eileen, for her constant
encouragement and support.

Index

Colour pictures are indicated by the use of **bold** type for page numbers.

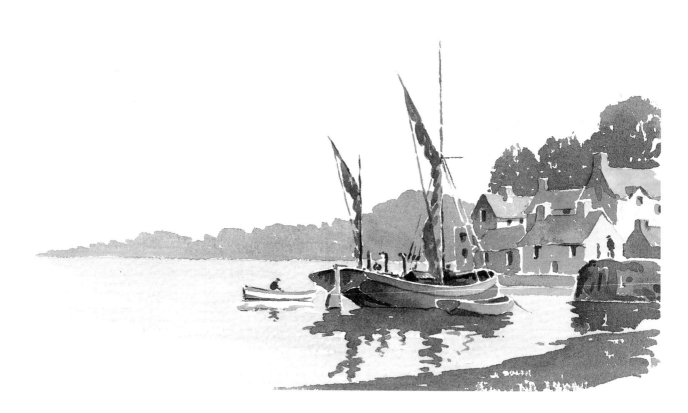